FROM THE FILMS OF

Harry Potter

100 OBJECTS

THE MOST ICONIC PROPS FROM THE MOVIES

FROM THE FILMS OF

Harry Potter

100 OBJECTS

THE MOST ICONIC PROPS FROM THE MOVIES

INSIGHT EDITIONS

SAN RAFAEL · LOS ANGELES · LONDON

CONTENTS

HARRY POTTER AND THE SORCERER'S STONE

1. Hagrid's Motorbike
2. Hogwarts Acceptance Letter
3. Harry Potter's Glasses
4. Leaky Cauldron Signs
5. Ollivanders Wand Boxes
6. Platform 9-¾ Train Ticket
7. Platform 9-¾ Sign
8. Hogwarts Express
9. Bertie Bott's Every Flavour Beans
10. Chocolate Frogs
11. Harry Potter's Trunk
12. House Points Hourglasses
13. Sorting Hat
14. Gryffindor Dormitory Beds
15. Neville Longbottom's Remembrall
16. Charms Class Feather
17. Nimbus 2000 Broom
18. Golden Snitch
19. Quaffles and Bludgers
20. Invisibility Cloak
21. Mirror of Erised
22. Winged Keys
23. Sorcerer's Stone
24. Wizard's Chess Game

HARRY POTTER AND THE CHAMBER OF SECRETS

25. Floating Cake at Privet Drive
26. The Burrow Clocks
27. Molly Weasley's Self-Knitting Machine
28. Flying Ford Anglia
29. Ron's Broken Wand
30. Lucius Malfoy's Wand Cane
31. Gilderoy Lockhart's Painting of Gilderoy Lockhart
32. Gilderoy Lockhart's Books
33. Ron's Howler
34. Nimbus 2001 Broom
35. Polyjuice Potion Cauldron
36. Tom Riddle's Diary
37. Door to the Chamber of Secrets

HARRY POTTER AND THE PRISONER OF AZKABAN

38. Fat Lady Portrait
39. Knight Bus
40. Wanted Poster of Sirius Black
41. The Daily Prophet Newspaper
42. Sybill Trelawney's Teacups
43. Remus Lupin's Boggart Cabinet
44. Marauder's Map
45. Harry's Wand
46. Firebolt Broom
47. The Monster Book of Monsters
48. Sneakoscope
49. Hermione Granger's Time-Turner

HARRY POTTER AND THE GOBLET OF FIRE

50. Portkey
51. Rita Skeeter's Quick-Quotes Quill
52. Triwizard Cup
53. Goblet of Fire
54. Triwizard Tournament Welcome Feast Food
55. Yule Ball Invitation
56. Yule Ball Great Hall Decorations
57. Golden Egg
58. Pensieve
59. Pensieve Memory Bottles
60. Little Hangleton Graveyard Statue
61. Alastor Moody's Trunk

HARRY POTTER AND THE ORDER OF THE PHOENIX

62. Ministry of Magic Documents
63. Luna Lovegood's Dirigible Plum earrings
64. *The Quibbler* Magazine
65. Alastor Moody's Broom
66. Black Family Tapestry
67. *Dark Arts Defense: Basics for Beginners*
68. Dolores Umbridge's Blood Ink Quill
69. Educational Decrees
70. Dolores Umbridge's Cat Plates
71. Hog's Head Inn's Hog's Head
72. Dumbledore's Army Sign-Up Sheet
73. Prophecy Globe

HARRY POTTER AND THE HALF-BLOOD PRINCE

74. Weasleys' Wizard Wheezes Magician's Hat Statue
75. Weasleys' Wizard Wheezes Puking Pastilles Display
76. Weasleys' Wizard Wheezes Love Potions
77. Luna Lovegood's Spectrespecs
78. Butterbeer Label
79. *Advanced Potion-Making*
80. Felix Felicis Potion Bottle
81. Potion Bottle Labels
82. Marvolo Gaunt's Ring
83. Wanted Posters of Death Eaters
84. Horace Slughorn's Potions Trunk
85. Horace Slughorn's Hourglass
86. Cursed Opal Necklace
87. Crystal Cave Scoop
88. Vanishing Cabinet

HARRY POTTER AND THE DEATHLY HALLOWS–PART 1

89. Albus Dumbledore's Will
90. Xenophilius Lovegood's Deathly Hallows Necklace
91. Deluminator
92. Salazar Slytherin Locket
93. *The Tales of Beedle the Bard*

HARRY POTTER AND THE DEATHLY HALLOWS–PART 2

94. Ministry's Magic Is Might Statue
95. Painting of Albus Dumbledore
96. Hufflepuff Cup
97. Ravenclaw's Diadem
98. Nagini
99. Sword of Gryffindor
100. Elder Wand

INTRODUCTION

When Harry Potter receives his acceptance letter to Hogwarts School of Witchcraft and Wizardry, in *Harry Potter and the Sorcerer's Stone*, the Muggle-raised boy learns he's a wizard. As such, he acquires a wand for his magical studies, obtained at Ollivanders wand shop in Diagon Alley. In his first year at Hogwarts, Harry is given an Invisibility Cloak by an unnamed benefactor, which helps him research the maker of the Sorcerer's Stone. And he learns the sport of Quidditch, flown on brooms, where he becomes Seeker of the Gryffindor team and captures the Golden Snitch in order to win the game.

These and the other objects included in this book are often referred to as "hero props," as they are literally handled by the heroes, but they also serve to drive the story and are important to the development of the characters.

Many of the objects utilized or pursued by Harry, Ron, and Hermione seem to be exactly what you'd think upon first sight—and then it's discovered they are something else entirely. The Invisibility Cloak is one of the three Deathly Hallows, which grant power over death to the possessor. Headmaster Albus Dumbledore's wand—the Elder Wand—is another. The third, the Resurrection Stone, was hidden by Dumbledore in the first Golden Snitch Harry caught, which opens to him at one of his lowest points and serves to renew his faith in his mission to stop the Dark Lord Voldemort. The Resurrection Stone, housed in a ring, is also discovered to be one of seven Horcruxes Voldemort created in his desire for immortality, and which Harry, Ron, and Hermione must find in order to defeat him. Though the ring is seen only for short moments, its impact on the story is great.

Key objects in the Harry Potter films often began with a sketch by production designer Stuart Craig, who oversaw all the creative departments. Craig worked in tandem with set designer Stephenie McMillan, who sourced students' and professors' trunks, commissioned floating cakes, and rounded up hundreds of teacups for Divination class.

One of the most important philosophies behind the creation of the objects was "to have a richness in the materials," says prop modeler Pierre Bohanna. "Often how [filmmakers] go about things is to compromise and use paints and use cheap and quick materials just to work things out. [In Harry Potter] everything had to be of a quality. The idea was to make them how they would have been made: wands were made of precious woods, we used a lot of gold plating. It gives a richness and a luster."

The number of objects made for the Harry Potter films is remarkable. There were one thousand bottles filled and capped for potions classes, twelve thousand handmade books for classrooms, book shops, and whatever Hermione was reading for a little light research, and forty thousand packaged products on the shelves of Weasleys' Wizard Wheezes. All these objects and more were categorized, barcoded, and stored by prop master Barry Wilkinson and his dressing crew, who would ensure each handheld prop—most notably the wands—was returned to them at the end of a day's shooting.

Hattie Storey held the title of props art director. This is unique in the filmmaking world, but considerably important to the wizarding world, where the majority of its objects needed to be designed from scratch as few shops (at the time) actually stocked wands, cauldrons, or broomsticks. "The modelers and the props department created most everything," says producer David Heyman, "because most everything was specific to this world." It was Storey's job to coordinate design, drawing, and fabrication of the objects, "and for this, I relied on our team of superbly talented prop manufacturers led by Pierre Bohanna," says Storey, "which included sculptors, carpenters, painters and many other talented craftsmen at Leavesden Studios."

Other specially made objects were designed by concept artists with illustrations describing their form, texture, and materials for creation. Graphic designer Miraphora Mina was responsible for many intricate items, such as the Slytherin Horcrux locket, the opal necklace that cursed Gryffindor Katie Bell, and Horace Slughorn's green crystal hourglass. Adam Brockbank devised most of the special props for Weasleys' Wizard Wheezes joke shop, including a giant caricatured sculpture of a schoolgirl who vomits a constant stream of Puking Pastilles into a bucket, brought to life by the prop makers "in sickening detail," says Storey.

Miraphora Mina and Eduardo Lima led the graphics department, and designed and created everything from the Howler Ron Weasley receives in *Harry Potter and the Chamber of Secrets* to most of Lord Voldemort's Horcruxes. "For us," says Mina, "for every single design job we were given on the films, we had to enter the character of that person or the environment of that place or the history behind that moment, and it was our duty to try and help tell the story in that one moment with that one piece of graphic." Eduardo Lima explains the bottom line: "You always have to think of the storytelling," he says. "You need to tell that story with that prop."

Harry Potter 100 Objects showcases visual development art, behind-the-scenes information, screen captures, and commentary from the incredible artists who imagined and crafted one hundred important and influential objects that tell the story of Harry Potter, his friends and his foes, and his journey through the wizarding world.

TITLE PAGE: Hermione Granger (Emma Watson) prepares Polyjuice Potion in the second floor girls' bathroom in *Harry Potter and the Chamber of Secrets*
OPPOSITE: Albus Dumbledore (Michael Gambon) in the Astronomy Tower in *Harry Potter and the Half-Blood Prince*

1. HAGRID'S MOTORBIKE

Hogwarts Headmaster Albus Dumbledore and Professor Minerva McGonagall rendezvous in front of Number Four, Privet Drive, waiting for the arrival of the infant Harry Potter. Suddenly, a flying motorcycle comes down and skids to a halt. The motorbike is driven by Rubeus Hagrid, Keeper of Keys and Grounds at Hogwarts, who passes the baby to Dumbledore. Hagrid rides in on an enchanted vehicle, in this case, a 1959 Triumph Bonneville T120 motorcycle.

In *Harry Potter and the Deathly Hallows – Part 1*, Hagrid flies Harry away from Privet Drive in a robin's-egg blue Royal Enfield with the grown-up Harry settled into a Watsonian sidecar. "We tried very much to match the motorbike we used in *Sorcerer's Stone*, where Hagrid collected Harry as a baby and brought him to Privet Drive," says special effects supervisor John Richardson. "That motorbike had a pretty iconic look, but it was very, very difficult to get hold of. So we looked for another bike that was readily available, but matched the earlier one."

During their escape, Hagrid drives the motorcycle into a tunnel, then maneuvers it up the wall and upside down. Another motorcycle was retrofitted with straps and molded fiberglass seats strong enough to hold in a stuntman in a full-size Hagrid costume. Background plates and right-side-up stunts were filmed in Liverpool's Queensway Tunnel.

"Are the rumors true, Albus?"

"I'm afraid so, Professor. The good, and the bad."

"And the boy?"

"Hagrid is bringing him."

—ALBUS DUMBLEDORE AND MINERVA MCGONAGALL, *HARRY POTTER AND THE SORCERER'S STONE*

OPPOSITE BOTTOM: Rubeus Hagrid (Robbie Coltrane) arrives at Privet Drive with the baby Harry Potter in *Harry Potter and the Sorcerer's Stone*
OPPOSITE TOP: Hagrid's motorcycle's sidecar from *Harry Potter and the Deathly Hallows – Part 1*
LEFT: Hagrid (Robbie Coltrane) and Harry (Daniel Radcliffe) set out to evade Death Eaters in *Harry Potter and the Deathly Hallows – Part 1*
BELOW: Hagrid (Robbie Coltrane) delivers the rescued baby Harry to Albus Dumbledore (Richard Harris) and Minerva McGonagall (Maggie Smith) in *Harry Potter and the Sorcerer's Stone*

BEHIND THE MAGIC

Hagrid's motorbike arrives at The Burrow in *Harry Potter and the Deathly Hallows – Part 1*, and makes a crash-landing into the surrounding marsh, a stunt achieved by sending another rebuilt Royal Enfield down a track into a water-filled set, akin to a log flume ride.

To: Mr. Harry Potter,
 The Cupboard Under the Stairs,
 4, Privet Drive,
 Little Whinging,
 Surrey

Dear MR. POTTER..

 We are pleased to inform you that you have been accepted at Hogwarts School of Witchcraft and Wizardry.

Students shall be required to report to the Chamber of Reception upon arrival, the dates for which shall be duly advised.

Please ensure that the utmost attention be made to the list of requirements attached herewith.

We very much look forward to receiving you as part of the new generation of Hogwarts' heritage.

Draco Dormiens Nunquam Titilandus

Prof. McGonagall

Professor McGonagall

HOGWARTS SCHOOL of WITCHCRAFT & WIZARDRY
Headmaster: Albus Dumbledore, D.Wiz., X.J.(sorc.), S.of Mag.Q.

2. HOGWARTS ACCEPTANCE LETTER

When Harry Potter picks up the mail one morning, he finds a letter addressed to him from Hogwarts School of Witchcraft and Wizardry. His aunt and uncle, Petunia and Vernon Dursley, are not pleased with the acceptance letter for Harry from the school and destroy it. Letters continue to arrive, delivered by owls, but Vernon keeps destroying them. Then ten thousand letters addressed to Harry arrive, swirling around the house from the fireplace and the front door.

Most of the owls who waited patiently on the lawns, roofs, and street signs on Privet Drive were fake, but a certain number were trained to wear a plastic harness that was rigged to drop pieces of paper printed with Harry's address and "stamped" with a Hogwarts seal.

Harry Potter and the Sorcerer's Stone director Chris Columbus assumed the thousands of letters that flew into the house would be accomplished digitally, but visual effects supervisor John Richardson assured him that his crew could do this as a practical effect. The blizzard of letters that blew through the house were single sheets of paper. The letter is the first magical object seen in the films, and coincidentally, the first artifact the graphics department designed and created for the films. Graphic designer and props concept artist Miraphora Mina used a nibbed calligraphy pen with emerald green ink to address the envelope, imagining the character of Professor McGonagall's handwriting, especially her signature.

"Dad, look! Harry's got a letter!"

—DUDLEY DURSLEY, *HARRY POTTER AND THE SORCERER'S STONE*

The graphics department also designed the Hogwarts coat of arms, depicted in the wax seal on the back of the envelope.

OPPOSITE: The Hogwarts Acceptance Letter prop, sent to Harry in *Harry Potter and the Sorcerer's Stone*
TOP: Harry's Hogwarts Acceptance Letter envelope created by the graphics department
ABOVE: Harry Potter (Daniel Radcliffe) reads his Hogwarts Acceptance Letter
LEFT: Harry (Daniel Radcliffe) tries to catch one of thousands of letters swirling in Number 4, Privet Drive, watched by his uncle Vernon (Richard Griffiths) and cousin Dudley Dursley (Harry Melling)

3. HARRY POTTER'S GLASSES

Immediately as Daniel Radcliffe, Emma Watson, and Rupert Grint were cast in *Harry Potter and the Sorcerer's Stone*, they were swept into a photo shoot. ["The photographer] referred to all three of us, rather wonderfully," says Radcliffe, "and I say this without meaning it to come across as a criticism—I was 'the one in glasses,' 'the girl' was Emma, and Rupert was 'the other boy.' And I still find that very funny and quite charming, to be honest. We were the one in the glasses, the girl, and the other boy."

Daniel Radcliffe encountered some personal difficulties with Harry's glasses when he first began wearing them for the part. "For the first two weeks of the film, I had these unbelievable spots, terrible spots," he explains. "And although I did enter puberty incredibly young, I'd never gotten to the acne stage, and it seemed a bit odd that I had spots so quickly." Notably, these spots were in perfect circles where the glasses sat on Daniel's face. "It transpired I had a nickel allergy," says Radcliffe. "So if you're a more paranoid person, you might take it as an ill omen that Harry's glasses gave me a rash." The metal of the spectacles was quickly changed.

Over the course of the eight films, Radcliffe went through one hundred and sixty pairs of glasses, though they rarely had real lenses in them, to avoid lighting challenges in the studio or on location. During Quidditch games, however, a digital Golden Snitch could often be seen reflected in the glasses.

TOP: Harry's lens-less glasses
ABOVE: Harry (Daniel Radcliffe), *Harry Potter and the Half-Blood Prince*
OPPOSITE TOP: Ron Weasley (Rupert Grint) and Harry, *Harry Potter and the Sorcerer's Stone*
OPPOSITE BOTTOM LEFT: Continuity Polaroids for *Harry Potter and the Sorcerer's Stone*
OPPOSITE BOTTOM RIGHT: Publicity shot for *Harry Potter and the Half-Blood Prince*

BEHIND THE MAGIC

Daniel Radcliffe not only had an allergy to the nickel-plated glasses, but also to the green contact lenses he tried to wear as Harry. His reactions to these are visible in the last scene of *Harry Potter and the Sorcerer's Stone*, which was actually filmed in the first weeks of production.

> "Harry, your eyesight really is awful."
>
> —HERMIONE GRANGER, *HARRY POTTER AND THE DEATHLY HALLOWS – PART 1*

> "What did you do to your glasses? *Occulus Reparo*."
>
> "I definitely need to remember that one."
>
> —HERMIONE GRANGER AND HARRY POTTER, *HARRY POTTER AND THE CHAMBER OF SECRETS*

When filming came to an end, Daniel Radcliffe took the first and last pair of his character's glasses as a souvenir of his time as Harry Potter.

SORCERER'S STONE

15

At the bottom of the Leaky Cauldron selections sign: "All main courses are served with the following: potatoes either roast, baked, fried. Seasonal vegetables and a selection of moving . . . things"

4. LEAKY CAULDRON SIGNS

Harry is taken to the Leaky Cauldron by Hagrid, en route to Diagon Alley. This London tavern, set on Charing Cross Road, is Harry's first true encounter with the wizarding world. As Hagrid and Harry make their way to the seemingly unremarkable front door, a blank sign hanging above reveals an image of a three-legged cauldron and the establishment's name.

Once inside, to one side of the pub's bar, a chalkboard advertises the Cauldron's luncheon offerings. The signs were a collaboration between the prop and graphics departments, who would scour the novels for references, and then make up more on their own, subject to the production's approval. As the sign says, the Leaky Cauldron is known for its most excellent and delicious luncheon. Selections include Roast Hog, Game Pie, Pickled Eel, and the house specialty: Steak and Kidney Pie. There are also myriad soups listed on another chalkboard: Leaky House Soup, Soup House Leaky, and Soup Soup Soup are but a few of the options.

> "The Leaky Cauldron.
> Hey! If you have pea soup, make sure
> you eat it before it eats you."
>
> —DRE HEAD TO HARRY POTTER ON THE KNIGHT BUS, *HARRY POTTER AND THE PRISONER OF AZKABAN*

OPPOSITE TOP: Professor Quirinus Quirrell (Ian Hart) stands beside the Leaky Cauldron's daily menu in *Harry Potter and the Sorcerer's Stone*
OPPOSITE BOTTOM: A witch stands nearby the unremarkable entrance to the Leaky Cauldron in visual development art by Andrew Williamson
TOP: Logo for the Leaky Cauldron by the graphics department
ABOVE LEFT: Hagrid (Robbie Coltrane) takes Harry (Daniel Radcliffe) to the Leaky Cauldron before entering Diagon Alley
LEFT AND FAR LEFT: Leaky Cauldron signs explaining its services and fire emergency actions for *Harry Potter and the Prisoner of Azkaban*

5. OLLIVANDERS WAND BOXES

It is one of a young wizard's most important rites of passage to acquire their wand, and most visit Ollivanders, Makers of Fine Wands since 382 BC, situated on Diagon Alley. When Hagrid brings Harry to Ollivanders, current proprietor Garrick Ollivander slides into view on a twelve-foot-high moving ladder, the only way one can access the wands on the topmost shelves. The Ollivanders set was modest in size, rich in detail, and densely compacted with wand boxes. Seventeen thousand wand boxes.

Set decorator Stephenie McMillan was tasked with stocking Ollivanders wand shop. "If you think of a normal-size shop, think of store rooms at the back going up seventeen feet, all with shelves of wand boxes, and that's what we had to fill."

Each wand box was individually labeled according to its contents; occasionally decorations were added. "Some of them had tassels or cording," she said, "and all of them had labels, and were stamped with the Ollivanders logo." The labels, handwritten by the members of the graphics department, also listed each wand's core and type of wood. Additional information was written in runes or script styles from across the centuries.

> "I still need a wand."
>
> "A wand? Well, you'll want Ollivanders. T'ain't no place better."
>
> —HARRY POTTER AND RUBEUS HAGRID, *HARRY POTTER AND THE SORCERER'S STONE*

The boxes were aged, scratched, and sprinkled generously with what could possibly be centuries of dust.

OPPOSITE TOP: One of the many wand boxes created in a collaboration between the graphics and prop department
OPPOSITE BOTTOM: Wand master Ollivander (John Hurt) suggests Harry try out a wand in *Harry Potter and the Sorcerer's Stone*
OPPOSITE INSET: The sign for Ollivanders: Makers of Fine Wands Since 382 BC
LEFT: Seventeen thousand wand boxes were created for Ollivanders Wand Shop
BELOW: John Hurt as Garrick Ollivander

6. PLATFORM 9-¾ TRAIN TICKET

Harry Potter is escorted to King's Cross Station, from which he will leave on the Hogwarts Express, by Rubeus Hagrid. Hagrid has another errand to run, so he hands Harry his ticket, which states the train leaves from Platform 9-¾.

> "Now, your train leaves in ten minutes. There's your ticket. Stick to it, Harry, that's very important. Stick to your ticket."
>
> —RUBEUS HAGRID, *HARRY POTTER AND THE SORCERER'S STONE*

The ticket was designed by the graphics department, headed at the time by Miraphora Mina. "It's a total gift being asked to design anything for the wizarding world," says Mina. "We have a fantastic library at our design studio, so first thing we'll do is to immerse ourselves in reference material." For an artifact such as the ticket for Platform 9-¾, that process is centered around typography, which is the art of arranging letters and text in such a way to make the copy legible, clear, and visually appealing; as well as pattern design; and sometimes a little bit of architecture and color. For any item, the graphics department must consider what's on it. "What's the information that's on a ticket or a soup label or a poster or a newspaper," she continues. "All the incidental bits of information that are in a world at any time, at any place, that help tell the story." Mina admits, "You've got to be a bit of a geek to do that. But those are the tools we have to help shape how best to tell a story."

> The scenes at King's Cross Station for *Harry Potter and the Sorcerer's Stone* were shot on a Sunday, as it was the least busy day at the terminal. "It was a historic day for Harry Potter fans," says director Chris Columbus.

TOP: Early version of a ticket to the Hogwarts Express by the graphics department for *Harry Potter and the Sorcerer's Stone*
MIDDLE LEFT: Harry (Daniel Radcliffe) sticks to his ticket at Platform 9-¾
ABOVE LEFT: Final Platform 9-¾ ticket seen in *Harry Potter and the Sorcerer's Stone*

7. PLATFORM 9-¾ SIGN

Harry receives help to find Platform 9-¾ at King's Cross Station by Molly Weasley and her brood of ginger-haired children. Harry runs to the platform upon her advice and, once through the barrier, he sees the sign for Platform 9-¾. A range of emotions crosses Harry's face—surprise, wonder, happiness, and so much more—and the same has happened to viewers for more than twenty years since the film debuted.

"I think it's because that scene is about the potential for wonder in the middle of just everything around you being mundane," says Daniel Radcliffe. "King's Cross Station is just a fact of life rather than something amazing. I mean, it's great, it's wonderful! But it's the fact that something so amazing can happen in such normal circumstances is what makes that scene stand out for people."

Director Chris Columbus wanted the audience to feel what it was like going through the brick wall so, in a practical effect, he had a hollow wall constructed for Daniel Radcliffe to pass through. All other times, for anyone who disappeared through the wall, it was computer-generated.

> "Excuse me, excuse me.
> Excuse me, sir.
> Can you tell me where
> I can find Platform 9-¾?"
>
> "9-¾? Think you're
> being funny, do ya?"
>
> —HARRY POTTER AND TRAINMASTER,
> *HARRY POTTER AND THE SORCERER'S STONE*

BEHIND THE MAGIC

King's Cross Station is where the actors playing the Weasley family met for the first time. "We were all standing next to the Hogwarts Express," says Oliver Phelps (George Weasley), "and we heard this voice shout, 'Where are my boys?' Julie Walters, who plays our mother, appeared and I think that's when we knew that we were all going to be a pretty good match for the Weasleys."

THIS PAGE: Signs for the Hogwarts Express on Platform 9-¾ at King's Cross Station seen in the Harry Potter films

8. HOGWARTS EXPRESS

The Hogwarts Express transports new and returning students to Hogwarts School of Witchcraft and Wizardry every year. On his first train ride to school, Harry Potter meets Ron Weasley and Hermione Granger, who become his best friends, and aid Harry on his personal journey to defeat Voldemort.

"We couldn't shoot the scenes on a real train traveling through Scotland," says production designer Stuart Craig, "so we used helicopter shots of the train traveling through Scotland." The Hogwarts Express is "played" by a locomotive built in 1937, named "Olton Hall." It was renamed "Hogwarts Castle" and the Great Western Railway's standard train color of Brunswick green was changed to crimson. Window views of the Scottish Highlands were filmed from real moving trains, with aerial shots taken from helicopters. Actors in costume were positioned on the real trains, so the compartments would be occupied.

Scenes inside the train were filmed in front of a green screen. The look of the compartments was based on one of director Chris Columbus's favorite movies: 1964's *A Hard Day's Night*, starring the Beatles.

> **"London to Hogwarts for One Way Travel. Issued subject to the Rates & Regulations of the Hogwarts Express Railway Authorities"**
>
> —PLATFORM 9-¾ TICKET, *HARRY POTTER AND THE SORCERER'S STONE*

RIGHT: The Hogwarts Express, carrying witches and wizards between King's Cross Station in London to Hogwarts School of Witchcraft and Wizardry in Scotland
OPPOSITE: The Hogwarts Express winds its way through fields and valleys in *Harry Potter and the Order of the Phoenix*
FOLLOWING PAGES: ABOVE LEFT: Harry (Daniel Radcliffe) bids farewell to Hagrid before boarding the Hogwarts Express after his first year at Hogwarts in *Harry Potter and the Sorcerer's Stone*
BOTTOM LEFT: Harry (Daniel Radcliffe) shares a ton of sweets with new friend Ron Weasley (Rupert Grint) on the Hogwarts Express
RIGHT: The crimson-colored locomotive car of the Hogwarts Express

Four British Railways Mark 1 carriages were added to the Olton Hall locomotive. A fifth carriage, without compartments, was added for story purposes in *Harry Potter and the Half-Blood Prince*.

9. BERTIE BOTT'S EVERY FLAVOUR BEANS

Harry Potter and Ron Weasley bond before their first year at Hogwarts when Harry purchases a load of candy from the Trolley Witch on the Hogwarts Express to share with his new friend. As Ron works through the piles of Jelly Slugs and Ice Mice, Harry samples a box of Bertie Bott's Every Flavour Beans. Ron stresses that the name of the candy is not misleading.

The box for Bertie Bott's Every Flavour Beans was created by graphic designer Ruth Winick, who was given the brief that the packaging should have a British seaside feel and be fun to open. According to director Chris Columbus, actor Rupert Grint (Ron) "thought this was the greatest day of his acting career, because we were just letting him eat chocolate and candy all day."

An empty box of Bertie Bott's Every Flavour Beans helps introduce Ron's rat, Scabbers. While Scabbers digs around in the box, Ron tries a spell his brother Fred gave him to turn the "stupid fat rat" yellow. The spell causes only a slight glow inside the box and Scabbers backs out quickly (still brown). Both an animatronic and a real rat, named Dex, were used to make the special effects magic for this. A wire was attached to the box, and when the cue came, the box was pulled off Dex, making it appear as if he had backed out.

BEHIND THE MAGIC

On their first Christmas together, in *Sorcerer's Stone*, Ron munches on a box of Bertie Bott's Every Flavour Beans while he watches Harry open his presents.

"Anything off the trolley, dears?"
—TROLLEY WITCH ON HOGWARTS EXPRESS,
HARRY POTTER AND THE SORCERER'S STONE

10. CHOCOLATE FROGS

As Harry Potter and Ron Weasley feast on the sweets and treats Harry's purchased from the Trolley Witch, he opens a box labeled "Chocolate Frog." Harry is concerned they're real frogs, but Ron assures him it's just a spell. Chocolate Frogs are one of the wizarding world's most popular candies, not just because of their chocolaty goodness, but because each pack has a card featuring a famous witch or wizard. Harry's first card is of Albus Dumbledore.

The packaging for Chocolate Frogs was created by Ruth Winick, based on a brief by production designer Stuart Craig, who drew the shape of a pentagon for her. "[He] said I should think 'classical,'" says Winick, who used the Gothic architecture prevalent in Hogwarts castle's design for inspiration.

The graphics department was responsible for adding ingredients, slogans, and establishing dates on the Honeydukes candies boxes. The label for Chocolate Frogs includes information that 70 percent of a Chocolate Frog contains the finest *croakoa*—a mash-up of *croak* and *cacao*, aka "cocoa bean," the seed from which chocolate is made.

> "Watch it! Oh that's rotten luck. They've only got one good jump in them to begin with."
>
> —RON WEASLEY, *HARRY POTTER AND THE SORCERER'S STONE*

Chocolate is a good remedy to use after one encounters a Dementor, as seen when Remus Lupin offers Harry chocolate in *Harry Potter and the Prisoner of Azkaban*.

OPPOSITE TOP: Packaging for Bertie Bott's Every Flavour Beans created by the graphics department
OPPOSITE BOTTOM: Dispensers of Bertie Bott's Every Flavour Beans in Honeydukes sweetshop, seen in *Harry Potter and the Prisoner of Azkaban*
TOP AND LEFT: Boxes for Chocolate Frogs created by the graphics department
ABOVE: Harry (Daniel Radcliffe) watches as his Chocolate Frog gets his "one good jump" out the train in *Harry Potter and the Sorcerer's Stone*

11. HARRY POTTER'S TRUNK

Once he finds his way onto Platform 9-¾, Harry is surrounded by students, parents, and myriad trunks and cases. Every main character required their own trunk with their initials and school crest stamped on top. Many of these were acquired at flea markets and antique shops by set decorator Stephenie McMillan and her team. More trunks were acquired throughout the films, as well as cages for the students' companion animals.

> "You'll find that your belongings have already been brought up."
>
> —PERCY WEASLEY, *HARRY POTTER AND THE SORCERER'S STONE*

BEHIND THE MAGIC

Nineteen years after the events of *Harry Potter and the Deathly Hallows – Part 2*, Harry takes his children and their school supplies to the Hogwarts Express, including a trunk that belongs to Harry Potter's oldest son, James Sirius, with the initial J.S.P. embossed on it.

On the trunk is the Hogwarts crest, designed by the graphics department, who gave great attention to its details. "When we're thinking about a crest or an insignia," Miraphora Mina explains, "we're thinking about how we can bring the personality of the person or the institution into the design. What the details are that we choose to help tell that story." Mina researched medieval illustration, taking into account the age of the school, and the suggested traditions for a heraldic crest: a name or motto, a shield with its colors and elements, and a helmet or crown. The Hogwarts crest features the colors and mascot of the four Hogwarts houses. And the school motto on it? *Draco Dormiens Nunquam Titillandus*, which is Latin for "never tickle a sleeping dragon."

TOP: Student trunks seen in *Harry Potter and the Sorcerer's Stone*
LEFT: Images of trunks at Platform 9-¾
OPPOSITE TOP: The clock face from the House Points hourglass mechanism
OPPOSITE BOTTOM LEFT: Close-up of the house marker for Ravenclaw that adjusts its level to the house points earned, seen in *Harry Potter and the Half-Blood Prince*
OPPOSITE RIGHT: The House Points hourglasses show Slytherin in the lead during the Halloween holiday

12. HOUSE POINTS HOURGLASSES

Once the school year starts at Hogwarts, the four houses—Gryffindor, Ravenclaw, Hufflepuff, and Slytherin—compete to win the House Cup, which is awarded at the End-of-Term Feast. Points are given or taken by the Hogwarts professors and recorded in the Great Hall in hourglass-shaped cylinders filled with green, blue, yellow, or red gems.

Production designer Stuart Craig swapped out the precious jewels mentioned in the novels that filled the hourglasses for Indian glass beads. Acquiring the tens of thousands of beads needed is rumored to have caused a national shortage of red, green, yellow, and blue beads.

> "Your triumphs will earn you points. Any rule breaking, and you will lose points. At the end of the year, the house with the most points is awarded the House Cup."
> —MINERVA MCGONAGALL, *HARRY POTTER AND THE SORCERER'S STONE*

At the start of each film's school year, the prop makers made sure all the beads were placed at the top of each hourglass, as points had not yet been added or subtracted.

SORCERER'S STONE

> "When I call your name, you will come forth. I shall place the Sorting Hat on your head, and you will be sorted into your houses."
>
> —PROFESSOR MCGONAGALL,
> *HARRY POTTER AND THE SORCERER'S STONE*

LEFT: Professor Minerva McGonagall (Maggie Smith), who leads the Sorting Ceremony at Hogwarts, in a publicity still for *Harry Potter and the Sorcerer's Stone*
RIGHT TOP: Harry (Daniel Radcliffe) waits as the Sorting Hat contemplates his house assignment in *Harry Potter and the Sorcerer's Stone*
RIGHT MIDDLE AND BOTTOM: Professor McGonagall places the Sorting Hat on the heads of Draco Malfoy (Tom Felton) and Hermione Granger (Emma Watson)
OPPOSITE TOP: One of seven Sorting Hats constructed for the Harry Potter films
OPPOSITE MIDDLE: Continuity Polaroids of the Sorting Hat on a handmade stool constructed by the props department
OPPOSITE BOTTOM: First years anticipate their houses to be assigned by the Sorting Hat

13. SORTING HAT

At the beginning of the Hogwarts school term, first year students are sorted into one of four houses when the Sorting Hat is placed on their head and their house is announced. The Sorting Hat was created both practically and digitally. The hat placed on the students' heads had pieces of a real hat, topped by a framework used to line up registration points for motion-capture technology. The practical version of the hat was realized out of suede and lined with horsehair canvas.

Harry visits Dumbledore's office in *Harry Potter and the Chamber of Secrets*, and sees the Sorting Hat on a shelf. This hat was created entirely digitally.

Practical versions of the Sorting Hat were used in *Harry Potter and the Deathly Hallows – Part 2*, for the sorting of Lily Evans in Severus Snape's memories, and when Neville Longbottom (Matthew Lewis) pulls the Sword of Gryffindor from the hat. Over the course of the films, seven practical hats were created, each sporting different wrinkles, because, obviously, you never see them together!

> The leather Sorting Hat that announces each student's Hogwarts house was dyed, aged, and imprinted with Celtic symbols.

14. GRYFFINDOR DORMITORY BEDS

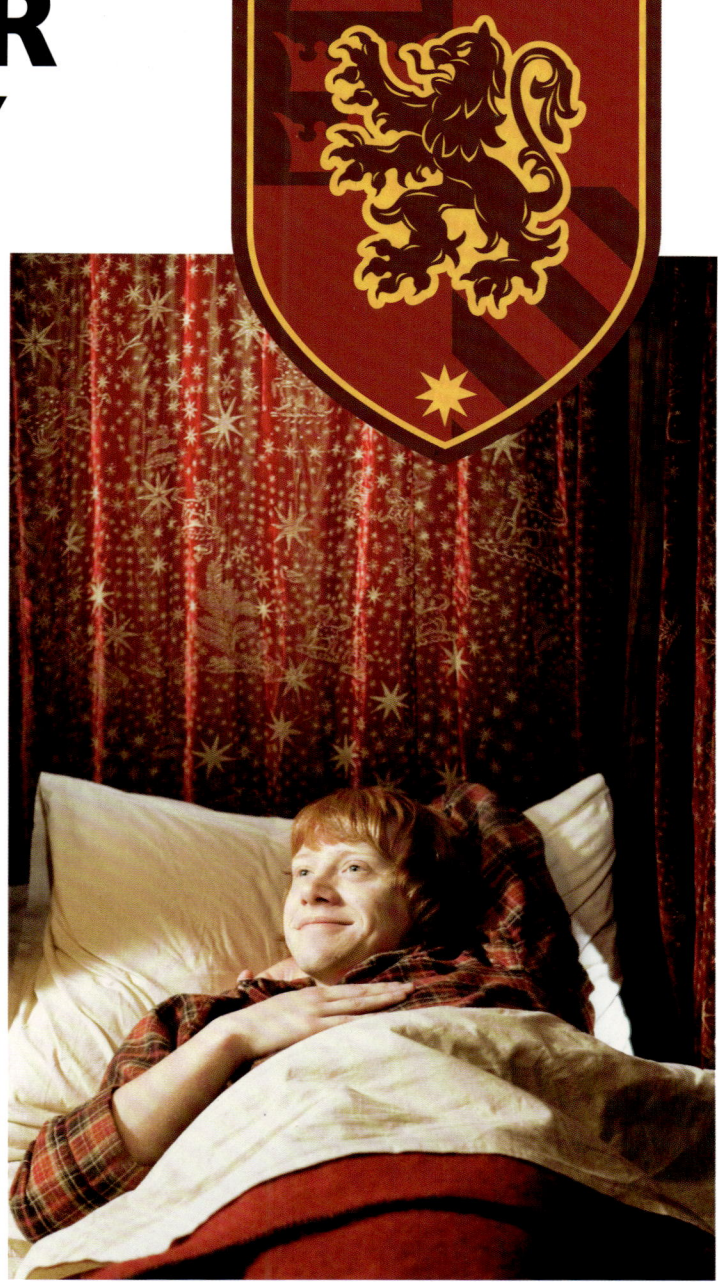

In Gryffindor Tower, five sturdy oak beds circle a heater in the Gryffindor Boys' Dormitory. It is here Harry sleeps, studies, and makes friends for life.

"Harry's lack of security was an aspect of his character that we wanted to explore," says Stuart Craig, "and in designing the dormitory we were very conscious of the fact that this was a refuge for him. He felt more at home here than anywhere else and we deliberately made it small. We draped the beds with curtains because they cocooned him; they made him feel comfortable and safe, which contrasted with the vastness of the rest of the place."

In order to make the room as protective and comfortable as possible, "we chose those little boxy four-poster beds because they're, in a way, womblike with the red curtains and plain solid posts," Stephenie McMillan explained. McMillan wanted the curtains to be Gryffindor scarlet, of course, printed with magical symbols. She searched antique markets and fabric stores for something to match her idea, but after some time, McMillan considered the curtain would have to be created for the film. Then, just before giving up the hunt, she spotted the very design she desired in a London shop window. "The design was what I wanted," McMillan said, "but unfortunately, the fabric was purple. Mauve, actually." McMillan told the shopkeeper she liked the pattern but not the color and was about to walk out the door, when the woman asked, "What color would you like it to be?" The fabric store was able to provide McMillan with curtain material the rich scarlet of the Gryffindor house colors.

> **"Boys' Dormitory is upstairs and down to your left. Girls' the same on your right."**
>
> —PERCY WEASLEY,
> *HARRY POTTER AND THE SORCERER'S STONE*

OPPOSITE TOP LEFT AND RIGHT: The five oak beds in the Gryffindor dormitory stayed the same size while the actors grew through the Harry Potter films
OPPOSITE BOTTOM: Harry (Daniel Radcliffe) studies the Marauder's Map while in bed in *Harry Potter and the Prisoner of Azkaban*
THIS PAGE: Ron Weasley (Rupert Grint) in his dormitory bed, sheltered by crimson and gold bed curtains in *Harry Potter and the Half-Blood Prince*

BEHIND THE MAGIC

Each boy's bed had a bedside table that reflected the interests of each student. Ron's had Chudley Cannon posters, Neville's had small plants, and Seamus's had shamrocks in support of the Irish National Quidditch team.

15. NEVILLE LONGBOTTOM'S REMEMBRALL

While the students are studying in the Great Hall one afternoon, the Owl Post drops off a package for Neville Longbottom containing a Remembrall from his Gran. If the smoke inside the Remembrall turns red, it means you've forgotten something.

The Remembrall was created personally by supervising modeler Pierre Bohanna. The Remembrall is glass, with an intricate pattern that Bohanna first drew onto the sphere with a pen, then etched out by tracing the lines with an electric rotary tool, to give them dimension. "The thing we really wanted to do with the props was to have a richness in the materials," Bohanna says. "[In Harry Potter] everything had to be of a quality. The ideal is to make them how they would have been made: wands were made of precious woods; we used a lot of gold plating. It gives a richness and a luster."

"Hey look—Neville's got a Remembrall."

—DEAN THOMAS,
HARRY POTTER AND THE SORCERER'S STONE

Prop modeler Pierre Bohanna, who created the Remembrall, jokes he doesn't remember how he made it.

TOP: The Remembrall, created by prop modeler Pierre Bohanna
MIDDLE: Continuity Polaroids of Matthew Lewis as Gryffindor Neville Longbottom for *Harry Potter and the Sorcerer's Stone*
ABOVE: Draco Malfoy (Tom Felton) takes Neville's Remembrall during Flying Class
RIGHT: Matthew Lewis as Neville Longbottom
OPPOSITE LEFT: Charms Professor Filius Flitwick (Warwick Davis) shows off his skill at *Wingardium Leviosa* in a publicity still for *Harry Potter and the Sorcerer's Stone*
OPPOSITE RIGHT: Hermione Granger (Emma Watson) is the first to levitate her feather as Ron watches

16. CHARMS CLASS FEATHER

For Professor Filius Flitwick's first Charms lesson at Hogwarts, he teaches them Levitation: the ability to make objects fly. Using a long white feather, he reminds them of the precise wrist movement to use, the "swish and flick," along with the incantation *Wingardium Leviosa*. Hermione successfully gets the feather to rise. Next to Harry, when fellow Gryffindor Seamus Finnigan attempts to cast the charm on his feather, it promptly explodes.

The day this scene was shot was the birthday of Devon Murray, who plays Seamus. "As soon as we finished filming," he recalls, "[producer] David Heyman brought in the biggest chocolate cake I'd ever seen in my life. It was huge. First of all, we had a party at lunch hour, then we had a party again when we finished filming. And I got to keep the feather I got to blow up."

> "I think we're going to need another feather over here, Professor."
> —HARRY POTTER, *HARRY POTTER AND THE SORCERER'S STONE*.

The "swish and flick" movement inspired wand choreographer Paul Harris as he developed a language of wand movements for wizards in *Harry Potter and the Order of the Phoenix*. "The flick of the wrist was a physical thing to be explored," Harris explains. "What made a wizard better? Well, it was physical: If you have a better swish and flick with your wand, your spell will be better. I was really keen on the 'swish and flick.'"

Actor Warwick Davis confessed that his absolute favorite thing to say as his character Flitwick was *Wingardium Leviosa*.

17. NIMBUS 2000 BROOM

There are many modes of transportation in the wizarding world, but perhaps none more ever-present than flying on a broom. Brooms are also flown by the players in Quidditch, the society's most popular sport. The Nimbus 2000 broom was the fastest broom available at the time.

The brooms ridden by the actors were made with an aircraft-grade titanium core covered by mahogany wood as they needed to be lightweight but strong. The Nimbus 2000 has a refined brown lacquered handle with the broom's logo engraved in gold at the tip. Its streamlined bristle head is bound in three thin gold-plated bands with an equally sleek tail made from birch branches.

In *Harry Potter and the Prisoner of Azkaban*, the Nimbus 2000 is destroyed when Harry is threatened during a game by Dementors circling the Quidditch pitch. Waking up in the hospital, he learns from Ron that the broom was destroyed when it fell into the Whomping Willow.

> **"That's not just a broomstick, Harry. It's a Nimbus 2000!"**
> —RON WEASLEY, *HARRY POTTER AND THE SORCERER'S STONE*

TOP: The Nimbus 2000 broom, "the fastest model yet!"
RIGHT: Harry Potter (Daniel Radcliffe) rides his new Nimbus 2000 broom, a gift from Professor McGonagall in *Harry Potter and the Sorcerer's Stone*
OPPOSITE: (Daniel Radcliffe) as Harry Potter with his Nimbus 2000 and Tom Felton as Draco Malfoy with the new Nimbus 2001 in a publicity still for *Harry Potter and the Chamber of Secrets*

> The brooms used in Madam Hooch's flying classes were created by the prop makers to be scraggly and well used, in order to be the complete opposite of the Nimbus 2000.

SORCERER'S STONE

37

The sound design team that gave the small, elegant ball a hummingbird-like sound as it whizzed by players' heads.

18. GOLDEN SNITCH

As the Seeker for the Gryffindor Quidditch team, Harry Potter is tasked with catching the Golden Snitch, worth one hundred and fifty points in the game. Roughly the size of a walnut, the Snitch has thin, ribbed wings in the shape of a sail that spring from its golden body.

The wings of the Golden Snitch went through several concepts before its final design. Credible aerodynamics were key to the creators, and so some wings resembled a moth's, whereas others are similar to fish fins or boat sails. The retraction and expansion of the wings was key to the design. "The Snitch has fluttering silver wings, which must be completely hidden while at rest," says Stuart Craig, and so the ball has two deep, narrow channels curving across its surface. "They look like surface decoration, but they're secretly hiding the wings." Art Nouveau–style lines were etched on, and each Snitch was electroformed in copper and then plated with gold.

Harry wins his first game with Gryffindor by catching the Golden Snitch . . . in his mouth. Director Chris Columbus remembers reading this and laughing out loud. "It was so completely unexpected," he says. Viewers do not actually see the Snitch go into Harry's mouth. "We worried about it," says sound designer Eddy Joseph, "but hoped by the time that he spat it out that people would think he hadn't swallowed it. We couldn't create a sound of him doing that, because that wouldn't have worked either, I don't think. So it was a little bit of a cheat."

> **"The only ball I want you to worry about is this . . . the Golden Snitch."**
>
> —OLIVER WOOD, *HARRY POTTER AND THE SORCERER'S STONE*

OPPOSITE: The Resurrection Stone was placed in the first Golden Snitch Harry caught and bequeathed to him by Albus Dumbledore in *Harry Potter and the Deathly Hallows – Part 1*
TOP: The Golden Snitch in flight
MIDDLE: Visual development art for the Golden Snitch by Gert Stevens for *Harry Potter and the Sorcerer's Stone*
LEFT: Harry Potter (Daniel Radcliffe) holds a Golden Snitch for the first time

19. QUAFFLES AND BLUDGERS

The game of Quidditch employs other types of balls in addition to the Golden Snitch. The Quaffle is a large red ball used to score points by passing it through one of three hoops. Bludgers are whacked by bats (held by two Beaters on each team) in an effort to knock the opposing team players off their brooms to prevent points.

Supervising modeler Pierre Bohanna wanted to give the general impression of the Quidditch elements as having a well-used feel, as it was school equipment that had been used for who knows how many years. "Everything was pretty worn and knackered," he says. The Quaffle began with a wax version of the prop called a patent, "a master shape we make our molds from," Bohanna explains.

> "The Quaffle is released . . . and the game begins!"
>
> —LEE JORDAN, *HARRY POTTER AND THE SORCERER'S STONE*

"We used sheet wax to give us the leatherette texture, the embossing of the Hogwarts crest, and all the stitching like an old-school heavy football." Four Quaffles were made for *Harry Potter and the Sorcerer's Stone*. To the sound design team, the Quaffle felt like "a ball within a ball," says sound designer Eddy Joseph. "There was reverberant movement in it, but you barely heard it."

Bludgers are the heaviest and most dangerous balls in the game. In order to give the Bludgers their metallic appearance, iron powder was used, followed by an acid to pull the rust out for the finish. Special arm guards, called "bays," were worn for safety, going from the shoulder to the wrist. Sound designer Martin Cantwell recorded his own voice for the Bludgers to make a "weird little nasty sound," giving a "Tasmanian Devil"–type spin on it.

TOP AND RIGHT: Concept art for a Bludger bat, a Quaffle, and the rust-tinged Bludger
ABOVE: Harry Potter (Daniel Radcliffe) flees a rogue Bludger in *Harry Potter and the Chamber of Secrets*
OPPOSITE TOP: Ron Weasley (Rupert Grint) struggles to quell his nerves before a Quidditch game as (left to right) his sister, Ginny (Bonnie Wright), Harry (Daniel Radcliffe), and Hermione (Emma Watson) look on in *Harry Potter and the Half-Blood Prince*
OPPOSITE BOTTOM: Quidditch equipment trunk, with chains that hold the eager Bludgers in place

BEHIND THE MAGIC

To make Ron Weasley appear untalented and clumsy during his tryout for the team in *Harry Potter and the Half-Blood Prince*, the stunt crew threw multiple Quaffles at him at a time to fluster actor Rupert Grint.

> "Bludger. Nasty little buggers."
>
> —OLIVER WOOD, *HARRY POTTER AND THE SORCERER'S STONE*

22. WINGED KEYS

As Harry, Ron, and Hermione pursue the Sorcerer's Stone in order to prevent it from falling into the wrong hands, they enter a room with the way out locked off. Inside, there is only a hovering broom, and a flock of what Hermione assumes are birds, but they are really keys. Harry and Ron reason that they must acquire the key that opens the door, and Harry will fly on the broom to catch it.

The design of the keys is simple. However, "The more beautiful you make something, the more nonthreatening it becomes," explains visual effects supervisor Robert Legato. And the artists wanted the keys to be scary and wild, "but not too scary or too wild," he continues. The keys needed to be intimidating rather than menacing, so the threat comes more from the movement of the keys.

Once Harry touches the broom, the keys begin to encircle and attack him. He manages to fly up to the key he needs, with the other keys in fast pursuit. The flight of these digital keys was designed to be in concert, just like a flock of birds.

> "What are we going to do? There must be a thousand keys up there."
>
> —HERMIONE GRANGER,
> *HARRY POTTER AND THE SORCERER'S STONE*

The key that opens the door was a practical model, with wings made from iridescent shot silk.

TOP: The practical model of the winged key that opens the door in *Harry Potter and the Sorcerer's Stone*
ABOVE: Harry (Daniel Radcliffe) flies through the flock of winged keys in his pursuit of the Sorcerer's Stone
LEFT: Concept art of the winged keys by Gert Stevens
OPPOSITE TOP: The ruby-colored Sorcerer's Stone
OPPOSITE MIDDLE: Harry (Daniel Radcliffe) discovers the Sorcerer's Stone in his pocket when confronted by Voldemort
OPPOSITE LEFT: The Sorcerer's Stone was re-created from the original mold for *Fantastic Beasts: The Crimes of Grindelwald*, where it was seen in the house of its maker, Nicolas Flamel

23. SORCERER'S STONE

Six versions of the Sorcerer's Stone were crafted, in different densities of red.

> "The Sorcerer's Stone is a legendary substance with astonishing powers. It will turn any metal into pure gold and produces the Elixir of Life, which will make the drinker immortal."
>
> —HERMIONE GRANGER, *HARRY POTTER AND THE SORCERER'S STONE*

In *Harry Potter and the Sorcerer's Stone*, Hagrid takes Harry to Gringotts bank and visits a vault himself to pick up a tiny package tied with string. It is the Sorcerer's Stone, which produces the Elixir of Life, giving the drinker immortality.

The brief given to the prop makers was that the Sorcerer's Stone should look like an uncut ruby. In its first iteration, the Stone was created out of molded resin, but on film it appeared more like a big piece of candy than a precious gem. In order to give the Stone a translucent quality, the filmmakers placed a small flame on top of the camera filming it; the light reflecting in the Stone gave it an extra hint of sparkle. The Stone was also rendered in different shades of red. "All the same tone, but just different strengths," says Pierre Bohanna, "because if it's [held in a] hand, it tends to get darker, whereas if you're holding it up and the light's going through, it gets very light."

Rupert Grint (Ron) got to keep a broken piece of his knight's horse when Ron sacrifices himself to be taken by the queen, allowing Harry to checkmate the king and win the game.

24. WIZARD'S CHESS GAME

Before she leaves for the Christmas holiday, Hermione finds Harry and Ron playing a game of chess in the Great Hall. After the queen is magically moved into position by Ron, the piece picks up her throne and destroys Harry's knight. In order to attain and protect the Sorcerer's Stone, Harry, Ron, and Hermione play another game of wizard chess. However, this game is life-size and more dangerous.

Harry Potter and the Sorcerer's Stone director Chris Columbus always preferred to create effects practically whenever possible, and having the chess game use very few digital effects made him feel, as he says, "like a kid in a candy store." Thirty-two chess pieces were sculpted in clay and cast in different materials necessary to their use. The pieces reached up to twelve feet high, and after their armaments—swords, maces, armor, and even the bishop's staffs create by the prop makers—were added, the pieces could weigh up to five hundred pounds.

Being a game of wizard chess, when a piece was taken by the opposing side, they would need to battle, blow up, and crash to the ground, and so the young actors on the set needed to be protected. Instead of pyrotechnics, compressed air devices within the pieces were activated via remotes for a controlled explosion. The "broken" pieces that collected in board-side pits were not just smashed originals, but individually sculpted and cast. To complete the shot, digital dust and debris were added.

> "It's obvious, isn't it?
> We've got to play our way across the room. All right. Harry, you take the empty bishop's square. Hermione, you'll be the queenside castle. As for me, I'll be a knight."
>
> —RON WEASLEY, *HARRY POTTER AND THE SORCERER'S STONE*

HARRY POTTER AND THE CHAMBER OF SECRETS

25. FLOATING CAKE AT PRIVET DRIVE

In *Harry Potter and the Chamber of Secrets*, the Dursleys host a party, and so dispatch Harry to his bedroom, where he discovers Dobby the house-elf. Dobby escapes Harry's room and heads to the kitchen. There, he discovers a Windtorte Pudding that Petunia Dursley has prepared for dessert. With a snap of his fingers, Dobby sends the pudding to float until it stops above the head of one of their guests—and then lets it drop.

The pudding that floats from the kitchen to the living room was computer-generated. It was a real, baked Windtorte dessert, a creamy confectionary comprised of layers of whipped cream and meringue filled with fruit such as cherries, and decorated with fondant violets, prepared by the film company's home economists that fell atop actress Veronica Clifford's (Mrs. Mason) head!

> "Not to be rude or anything, but this isn't a great time for me to have a house-elf in my bedroom."
> —HARRY POTTER, *HARRY POTTER AND THE CHAMBER OF SECRETS*

The cake-levitating Dobby was the first fully computer-generated major character in the Harry Potter films.

TOP: The sugary violet Windtorte cake served by Petunia Dursley in *Harry Potter and the Chamber of Secrets*
RIGHT: Harry Potter (Daniel Radcliffe) tries to prevent a disaster as the Dursleys entertain guests when Dobby the house-elf levitates the Windtorte Pudding over the Masons (Jim Norton and Veronica Clifford)
OPPOSITE TOP RIGHT: Early concept art by Adam Brockbank of a wand-wielding wizard clock intended for the Weasleys' home
OPPOSITE LEFT: The colorful grandfather clock in the Weasleys' home
OPPOSITE MIDDLE: Concept art of The Burrow by Andrew Williamson
OPPOSITE RIGHT: Preliminary design for The Burrow clock by an unidentified artist

26. THE BURROW CLOCKS

In addition to seeing blankets being magically knitted, and saucepans seeming to wash themselves when Harry Potter visits the Weasleys' home, Harry is amazed at a multicolored painted grandfather clock featuring eight hands instead of two. Instead of pointing to hours and minutes, the hands, which each hold a moving image of a Weasley (Fred and George are on the same hand), indicate where that family member is at any given time.

The hands of this clock were created by the props department from antique scissors, and engraved with the family names on the blades. The finger holds were covered with green-screen material so the family faces could be placed digitally in postproduction. The clock was re-created for *Harry Potter and the Half-Blood Prince*, unpainted this time, and instead of images, the finger holds on the hands bore the first initial of each family member (Fred and George still shared a blade). "That's my favorite prop from all the films," says Daniel Radcliffe. "It shows where they are and what's happening to them, even if they're in mortal peril."

BEHIND THE MAGIC

The props within The Burrow were fanciful and a form of enticement for the actors. "That kind of stuff is great," says Mark Williams, who plays the Weasley father, Arthur. "Even the grown-up actors had to be told: 'Don't touch the props! Stop poking around! Leave them alone!'"

"It's not much, but it's home."

—RON WEASLEY, *HARRY POTTER AND THE CHAMBER OF SECRETS*

CHAMBER OF SECRETS

51

27. MOLLY WEASLEY'S SELF-KNITTING MACHINE

Ron, Fred, and George Weasley use a flying car to drive Harry to their home, The Burrow, when they learn he's trapped at the Dursleys.

Magic is part of The Burrow's home life, being a wizard home. Upon entering, Harry spies a brush scouring a pan clean by itself in the kitchen sink. There's also a large afghan blanket in the process of being knitted magically. "The knitting machine was actually a machine that knitted itself," says Julie Walters, who plays the Weasley matriarch, Molly. "Lots of things people thought were a camera trick actually worked." The effect was a simple practical one. Behind the blanket is a mechanical device that holds the piece up while it moves two knitting needles back and forth. In order to create realistic movement, the mother of one of the crew members was filmed knitting for several hours as reference.

> "Where have you been? . . . Beds empty, no note, car gone. You could have died! You could have been seen!"
>
> "They were starving him, Mum. There were bars on his window!"
>
> —MOLLY WEASLEY AND RON WEASLEY,
> *HARRY POTTER AND THE CHAMBER OF SECRETS*

✦

Stephenie McMillan also decorated the house with Mrs. Weasley's choice craft in mind, employing dedicated knitter Shirley Lancaster to create pillow tops and tea cozies. Every knitted sweater, scarf, or hat was handmade for the films. Among the many items specially knitted for the sets was Ron's patchwork bed cover in the bright orange and red colors of his favorite Quidditch team, the Chudley Cannons, said to be McMillan's favorite prop.

ABOVE AND OPPOSITE TOP RIGHT AND BOTTOM: Knitted creations by Molly Weasley (actually by knitter Shirley Lancaster) add a warm touch to the Weasley home
LEFT: Julie Walters as Molly Weasley, wearing a knitted coat in *Harry Potter and the Deathly Hallows – Part 2*
OPPOSITE TOP LEFT: Another knitted embellishment by Molly Weasley (Julie Walters) seen in *Harry Potter and the Chamber of Secrets*

The filmmakers believed that the Weasley house must be chilly, which is why Molly takes every opportunity to knit.

28. FLYING FORD ANGLIA

When Harry and Ron cannot get through Platform 9-¾ to catch the Hogwarts Express, they must find another way to get to Hogwarts. Having rescued Harry from being held captive in his aunt and uncle's house utilizing his father's magical car, the "Flying" Ford Anglia, Ron decides they should use the vehicle again and they fly to school.

"These were some of the best filming days, and Rupert and I had great fun," Daniel Radcliffe recalls. "Me and Rupert going psycho everywhere; I don't think we ever stopped laughing. Being in the flying car was like being on a fun fair ride. And I got to do some really good stunts, as well. That was the first time I really did some proper stunts."

> "Ron . . . I should tell you . . . Most Muggles aren't accustomed to seeing a flying car."
> —HARRY POTTER, *HARRY POTTER AND THE CHAMBER OF SECRETS*

Daniel Radcliffe remembers that in the flying car sequence, "I was actually hanging out the door, thirty-five feet up in the air, which was really cool."

Fourteen light blue 1962 Ford Anglia 105Es were needed for filming, "from mint condition when the boys rescue Harry from the Dursleys," says special effects designer John Richardson, "through it getting mangled in the tree and, finally, going wild in the forest." The "flying" version was gutted to make it lighter, then fitted onto a rotating crane with a gimbal head, so that it could rotate, pitch, and roll backward and forward. The gimbal head was also attached to the back of a specially adapted pickup truck to create even more flying effects with it. "Most of the Ford Anglias we found were not roadworthy and were headed for the scrap heap," Richardson adds, "so it wasn't a case of destroying vintage cars." Some of these cars were cut in half to allow for filming inside, others had new engines swapped in for high-speed driving, and yet more were smashed in various stages for the car that's "whomped" in the Whomping Willow. The special effects team also built several cars that appeared as if they had been running wild in the Forbidden Forest for a year.

TOP: One of fourteen Ford Anglia cars used for Harry and Ron's flight to Hogwarts in *Harry Potter and the Chamber of Secrets*
MIDDLE LEFT: Ron (Rupert Grint) and Harry (Daniel Radcliffe) (and an animatronic owl playing Hedwig) en route to Hogwarts
LEFT: The banged-up Flying Ford Anglia, looking a little less capable of flight
OPPOSITE TOP: Ron Weasley's (Rupert Grint) broken wand, tenuously held together by Spellotape
OPPOSITE RIGHT: Ron's spells go terribly wrong when he waves his broken wand
OPPOSITE BOTTOM: Thankfully, Ron (Rupert Grint) acquires a new wand after his family wins a *Daily Prophet* contest, as seen in *Harry Potter and the Prisoner of Azkaban*

29. RON'S BROKEN WAND

As a result of being "whomped" when Harry and Ron crash into the Whomping Willow on the grounds after they fly to Hogwarts, Ron's wand is broken in *Harry Potter and the Chamber of Secrets*. Even though he tries to repair it, this leads to several spells that backfire.

When Draco Malfoy insults Hermione Granger, Ron comes to her defense by casting "Eat slugs!" and it fails miserably, causing Ron to expel a cornucopia of slimy gastropods. "That was my favorite scene," says Rupert Grint. "I had to put these giant slugs in my mouth and then spit them out with all this lovely goo." The "slime" of the three plastic slugs, which were named Monty, Vincent, and Ethel, was flavored with either chocolate, lemon, orange, or peppermint.

When the Weasleys become the grand prize winners in a *Daily Prophet* contest in *Harry Potter and the Prisoner of Azkaban*, they're able to get Ron a new wand.

> In an attempt to fix it, Ron binds the broken halves of this wand with "Spellotape," which is a wizardy version of the British Muggles' Sellotape.

> "That wand needs replacing, Mr. Weasley."
>
> —TRANSFIGURATION PROFESSOR MINERVA MCGONAGALL, *HARRY POTTER AND THE CHAMBER OF SECRETS*

30. LUCIUS MALFOY'S WAND CANE

Lucius Malfoy is the father of Harry Potter's nemesis at Hogwarts, Draco Malfoy. The elder Malfoy works at the Ministry of Magic and is on the Board of Governors for Hogwarts. He is a pure-blood wizard of wealth and style, and will do anything to maintain that standing.

When Jason Isaacs was cast as Lucius Malfoy, he made a request of director Chris Columbus. "I said, I thought I'd have a walking cane," says Isaacs, "and he went why? Is something wrong with your leg?" Isaacs thought it would be a nice affectation for the character. Then he suggested that his wand come out of the cane. Columbus reminded him that the wizards' wands usually were kept in their sleeves. "I said, yes, but I was thinking mine could come out of my cane." What Isaacs considers the deciding factor was when Daniel Radcliffe said that not only did the idea sound cool, but that it would be great for the character's toy versions. "And sure enough, they sell these all over the world," he laughs.

Lucius Malfoy's wand has a sleek black shaft topped by an open-mouthed silver snake's head with inset emerald eyes, which proclaims his Slytherin roots. The snake head has replaceable teeth, as these would often break off when Isaacs used the cane too energetically.

BEHIND THE MAGIC

Voldemort takes Lucius's wand in *Harry Potter and the Deathly Hallows – Part 2*. "What is even more humiliating to Lucius is that Voldemort snaps off the emerald-eyed snake head from the wand," says Jason Isaacs (Lucius), "and chucks it in front of me."

> "Do enjoy yourself, won't you? While you can."
>
> —LUCIUS MALFOY TO HARRY POTTER,
> *HARRY POTTER AND THE GOBLET OF FIRE*

OPPOSITE: Jason Isaacs as Lucius Malfoy
TOP: Lucius Malfoy's snake-headed walking cane hides his wand
RIGHT: Lucius Malfoy (Jason Isaacs) confronts Harry (Daniel Radcliffe) in Albus Dumbledore's (Richard Harris) office in *Harry Potter and the Chamber of Secrets*

As Gilderoy Lockhart is a fake himself about his travels, the graphics team covered his books in fake snakeskin or lizard skins.

100 OBJECTS

60

32. GILDEROY LOCKHART'S BOOKS

Prior to his time teaching at Hogwarts, Gilderoy Lockhart was an acclaimed author memorializing his adventures in *Break with a Banshee*, *Gadding with Ghouls*, and *Wanderings with Werewolves*. Each book displays a moving photograph on the cover, with Lockhart dressed in an outfit that depicts him breaking, gadding, or wandering. Furthermore, he has covered his classroom with framed portraits of himself from the books and other adventures. "There aren't enough images for Gilderoy Lockhart in his life," says the actor who portrays him, Kenneth Branagh.

Both moving and nonmoving images were created of Gilderoy Lockhart for book covers and framed portraits. Branagh would be filmed in front of a green screen with props that would portray him traveling with trolls or voyaging with vampires, wearing a costume that fit the subject. "I remember spending an enormous amount of time in preproduction doing photography that was showing Gilderoy Lockhart as the greatest Quidditch master of all time," says Branagh, "and the greatest explorer of all time and a man of every conceivable kind of gift. [I] wore every costume under the sun. Costume designer Lindy Hemming and I had a wonderful time concocting all these personae who are part of what Gilderoy Lockhart writes about in his endless series of autobiography."

> "I see you've all bought a complete set of my books. Well done."
>
> —GILDEROY LOCKHART, *HARRY POTTER AND THE CHAMBER OF SECRETS*

The filmed piece and static photograph would be combined and later be composited digitally onto a book, always bordered by elaborate gold framing. Two versions of each book were created. "We had green-screen material on the book for the bookshop and for when he's signing the books," graphic designer Miraphora Mina explains. "But also had multiple versions of a completely finished book." For the books that wouldn't be seen so closely on camera, such as those held by students in the back of class, a static version of the cover was used.

34. NIMBUS 2001 BROOM

In his second year on the Gryffindor Quidditch team, Harry is surprised to find that Draco Malfoy has become the Seeker for the Slytherin team. Draco's father, Lucius, has bought the entire team the Nimbus Broom Racing Company's latest—and fastest—model: the Nimbus 2001.

The Nimbus 2001 is jet-black, with a silver band binding an even more aerodynamic and streamlined bristlehead than the previous model. The sleeker the branches in the bristlehead, the better the broom. Its straight handle ends in a newly designed and silver Nimbus 2001 logo. Added to the broom for this iteration are foot pedals that resemble those of a bicycle, also in silver. Previously, broom pedals were simple shapes upon which the riders would tuck their feet, similar to jockeys.

Actor Tom Felton describes his filming of the sport in the second film as "old school Quidditch." "Nowadays it's robotic and very clever camera apparatus," he says. "Back in my day, it was like being on a seesaw. We had one guy at one end with a lot of weights holding it, and then you at the other end with a bicycle seat with a broom on it. With the green screen behind you, they blow wind in your face, and tell you to look at point A and then point B, grab for this and grab for that. You really have no idea what's going on." When Felton viewed the completed Quidditch scenes, he was reasonably stunned. "I was like, wow! When did I do the flip? When did I do all those movements? So it's very, very cool how they did that."

> "Those are Nimbus 2001s. How did you get those?"
>
> "A gift from Draco's father."
>
> —RON WEASLEY AND MARCUS FLINT,
> HARRY POTTER AND THE CHAMBER OF SECRETS

BEHIND THE MAGIC

The designs for the Nimbus line of brooms used in *Sorcerer's Stone* and *Chamber of Secrets* and the Firebolt seen in *Harry Potter and the Prisoner of Azkaban* were created for "mass appeal." Otherwise, brooms were made to match the character's personality. Foot pedals and seats were tailored for the rider, in different metals and with either extravagant ornamentation or none at all on the broom collars and pedals.

35. POLYJUICE POTION CAULDRON

When the Heir of Slytherin is released and petrifies students and others in Hogwarts, Ron, Harry, and Hermione agree they need to speak with Slytherin students to get more information. Hermione proposes they take Polyjuice Potion—a potion that allows the drinker to temporarily transform themselves into the physical form of another—then infiltrate their dormitory, and ask who the Heir could be or who opened the Chamber.

Hermione finds the instructions for the potion in the book *Moste Potente Potions,* created by the graphics department, and sets herself up in the girls' lavatory on the second floor. This will assure privacy—no one uses it due to its resident ghost, Moaning Myrtle. Hermione sets up a large black cauldron atop a flame, along with a kit of ingredients and tools she will need to prepare it. It does take several weeks to make the potion, which lasts for an hour.

In order to transfer Harry Potter to The Burrow for his protection in *Harry Potter and the Deathly Hallows – Part 1*, six members of the Order of the Phoenix take Polyjuice Potion to act as decoys for any following Death Eaters. This scene was one of the most complex to film in the entire series, involving layers of live and CG animation composited together, resulting in the multiple Harrys.

> "I've never seen a more complicated potion."
>
> —HERMIONE GRANGER,
> *HARRY POTTER AND THE CHAMBER OF SECRETS*

More than two hundred cauldrons were used on the films, some heated up by working Bunsen burners.

OPPOSITE TOP: The Nimbus 2001 broom prop
OPPOSITE BOTTOM: Slytherin Quidditch players Marcus Flint (Jamie Lee Yeates), Adrian Pucey (Scot Fearn), and Draco Malfoy (Tom Felton) show off the Nimbus 2001 brooms bought for their team by Draco's father, Lucius
TOP, LEFT, AND ABOVE: Instructions for brewing Polyjuice Potion from *Moste Potente Potions* and a Polyjuice Potion bottle label, all handmade by the members of the graphics department for *Harry Potter and the Chamber of Secrets*
MIDDLE: Hermione Granger (Emma Watson) checks the status of Polyjuice Potion she is brewing in the second floor girls' bathroom in order to find the Heir of Slytherin

36. TOM RIDDLE'S DIARY

As a student at Hogwarts, Tom Riddle, later Lord Voldemort, endeavored to gain immortality by creating Horcruxes: a way to protect one's body by concealing a part of one's soul in an object or a living thing. The first object with which Riddle achieves this is a diary. The pages of this diary were blank, and could be used as a form of communication between a current writer and the Riddle maintained in the Horcrux. The diary falls into the hands of Ginny Weasley and possesses her to release the Basilisk, which goes after non-pure-blood students.

> "Funny, isn't it? The damage a silly little book can do? Especially in the hands of a silly little girl."
>
> —TOM RIDDLE, *HARRY POTTER AND THE CHAMBER OF SECRETS*

Being in the Chamber of Secrets, "instantly brought them together," says Bonnie Wright of her character's relationship with Harry. His obsession with his *Advanced Potion-Making* book in *Harry Potter and the Half-Blood Prince* brings them even closer. "Ginny experienced something similar when she became obsessed with Tom Riddle's diary and almost lost her life in the Chamber of Secrets," Wright explains. "She sees the parallels there. No one else can relate to him like she can."

Harry stabs the diary with a Basilisk fang to destroy it. The diary appears to "bleed" in a practical effect using a tube beneath the book that pumped out black fluid.

BEHIND THE MAGIC

Somewhere between forty to sixty versions of the diary were created, starting out new and fresh, then becoming stained with ink, waterlogged as a result of being thrown into a toilet, and finally stabbed with a Basilisk fang.

OPPOSITE TOP AND INSET: Harry Potter (Daniel Radcliffe) writes in Tom Riddle's diary in *Harry Potter and the Chamber of Secrets*, which transports him to an earlier time at Hogwarts
OPPOSITE BOTTOM: The destroyed diary on Dumbledore's desk in *Harry Potter and the Half-Blood Prince*
THIS PAGE: Two views of the destroyed Horcrux diary that Voldemort created to hide a portion of his soul

37. DOOR TO THE CHAMBER OF SECRETS

The Chamber of Secrets, hidden in the dungeons of Hogwarts, houses a deadly beast. In Harry's second year, that beast, the Basilisk, has been released from its confinement and is now attacking non-pure-blood students.

Harry, Ron, and Professor Lockhart find their way to the entrance of the Chamber. Approaching a large, locked circular door inset with seven snakes, Harry speaks to it in Parseltongue to open it. The snakes pull back one by one as an eighth snake comes from the bottom and circles around the frame in serpentine waves as it unlocks. At the same time, the tails of the snakes wrap around the door's practical hinge.

This was not a computer effect, but a practical device designed by special effects supervisor John Richardson and built by special effects supervising engineer Mark Bullimore, who also crafted the door locks to the Gringotts bank vaults. "That was a very clever piece of engineering," says production designer Stuart Craig. "Very clever, yes." The door was finished as aged and pitted rusty metal.

> "The Chamber is said to be home to something that only the heir of Slytherin can control. It is said to be the home . . . of a monster."
>
> —MINERVA MCGONAGALL, *HARRY POTTER AND THE CHAMBER OF SECRETS*

BEHIND THE MAGIC

The Chamber of Secrets was entered again in *Harry Potter and the Deathly Hallows – Part 2*, so Ron and Hermione could retrieve a Basilisk fang to destroy the Hufflepuff cup Horcrux. The set itself was a digital construction as it would be seen only briefly, but the original door and lock mechanisms were used to gain entrance.

HARRY POTTER AND THE
PRISONER OF AZKABAN

LEFT AND OPPOSITE TOP: Covers of the *Daily Prophet* created for *Harry Potter and the Deathly Hallows – Part 1*, after the Ministry of Magic takes over the newspaper BOTTOM: Hermione Granger (Emma Watson), subscription holder to the *Daily Prophet*, reads an issue published during the events of *Harry Potter and the Half-Blood Prince* OPPOSITE BOTTOM: Harry (Daniel Radcliffe), Ron (Rupert Grint), and Remus Lupin (David Thewlis) at Grimmauld Place, where the Order of the Phoenix meets in *Harry Potter and the Order of the Phoenix*

41. THE *DAILY PROPHET* NEWSPAPER

The wizarding world's most popular source for news is the *Daily Prophet*. But in addition to doling out daily news to the wizard community, the *Daily Prophet* became something of a character itself in the Harry Potter films.

Being able to utilize the wizarding world's moving images instead of static photographs was a great inspiration to the graphic designers of the *Daily Prophet*, who wondered if the design of the text could have a similar magic to it. "We didn't know at first if the text might move as well," says Miraphora Mina, "and that was probably one of the reasons that the pages have the text in spirals and shapes." This unconventional design would also give movement to the page if there were no moving pictures shown.

> ### BEHIND THE MAGIC
>
> The graphics department printed and assembled more than forty editions of the *Prophet* with multiple copies of each, "although we did reprint parts of the interiors, when they wouldn't be seen on camera," admits Miraphora Mina.

The *Prophet's* cover page typically fashioned its text blocks in a design that complemented the story: When the Weasleys win a trip to Egypt, in *Harry Potter and the Prisoner of Azkaban*, the headline is presented in the form of a pyramid. Rita Skeeter's story about Harry Potter and the Triwizard Cup in *Harry Potter and the Goblet of Fire* is placed within an outline of the cup. As the graphic designers were also tasked with writing copy beyond what the script required, they brought a sense of humor to it whenever possible. In an article about Sirius Black's escape from Azkaban, puns snake through the article: "It's Sirius," says the Ministry of Magic in one, another reads "Black is not Back!"

The Ministry of Magic eventually takes over the paper. "In the first three films, the *Daily Prophet* was more Gothic," says Eduardo Lima, who considers himself the "editor" of the *Prophet*. "But by the fifth film, the newspaper took on a more totalitarian tone with bold Soviet-era letters."

"[Director] David Yates asked us to look at Russian graphics," Mina says. "We also looked at newspapers from the 1940s. When something was really important, they would fill the whole page with one story. The design is always underpinned by the story," she continues. The height of the paper was reduced, and Yates also asked for everything to be printed on the horizontal.

> "Excuse me, little girl! This is for the *Daily Prophet*!"
>
> —DAILY PROPHET PHOTOGRAPHER, *HARRY POTTER AND THE CHAMBER OF SECRETS*

42. SYBILL TRELAWNEY'S TEACUPS

Sybill Trelawney teaches the art of Divination, an elective subject students are able to take in their third year. Her first lesson is the art of tessomancy—prediction of the future through the reading of tea leaves left after drinking a cup.

There were typically thirty-six students in each class at Hogwarts, and so set decorator Stephenie McMillan knew she would need at least that many teapots for this class. McMillan contacted the props department, hoping they'd not only be able to find enough crockery, but that they could come in time for her to dress the scene. She found the department had catalogued every single prop that had been used in the films so far. "They have storage down to a 'T,'" explained McMillan, who also liked the idea of recycling and reusing items from previous films rather than going out and buying new ones. When she asked if they could locate thirty-six teapots that had been used in *Harry Potter and the Sorcerer's Stone*, they showed up on set in twenty minutes.

In addition to the seventy-two teacups needed for the students, McMillan also wanted a stack of cups to be the centerpiece of the room. A blueprint of this teacup "cone" was designed by the draughts people and created by the prop makers. A central support pole with spoked rings at regular intervals was used to relieve weight on the rims of the lower cups.

> "Look in the cup— tell me what you see!"
>
> —SYBILL TRELAWNEY,
> *HARRY POTTER AND THE PRISONER OF AZKABAN*

TOP: Is it the Grim Professor Trelawney sees in Harry Potter's teacup for her first class?
ABOVE: Concept art by Andrew Williamson of Professor Trelawney's Divination classroom for *Harry Potter and the Prisoner of Azkaban*, featuring a "cone" of teacups
RIGHT: Harry (Daniel Radcliffe) and Ron (Rupert Grint) practice tessomancy in Divination class

Professor Trelawney's classroom held more than five hundred teacups, most stacked in a teacup "cone."

100 OBJECTS

43. REMUS LUPIN'S BOGGART CABINET

For his lesson against a Boggart in his Defense Against the Dark Arts class in Harry's third year, Professor Remus Lupin holds the creature inside a large cabinet while he teaches the students the counterspell for its banishment—*Riddikulus*!

Set decorator Stephenie McMillan chose to design Lupin's classroom with the look of a naturalist—someone who had kept dried flora and other specimens that he might have picked up during his travels—but she wanted the Boggart cabinet to have a different feel. "We looked at French furniture, specifically in the Art Nouveau style," she explained. "The wardrobe was an amalgam of the curving, flowing Art Nouveau lines, but we made them chunkier than they should have been to be more threatening."

> To portray the Boggart's transition from the scary version to the laughable one, the visual effects designers created a swirling tornado of the Boggart's fearful and funny forms.

> "Boggarts are shape-shifters. They take the shape of whatever a particular person fears the most."
>
> —HERMIONE GRANGER,
> *HARRY POTTER AND THE PRISONER OF AZKABAN*

Neville Longbottom is first up to cast the charm. Upon Lupin's advice, he combines his two worst fears to create a literally ridiculous result: Professor Severus Snape dressed in Neville's gran's bird-topped hat and tweed ensemble. Actor David Thewlis (Lupin) remembers thinking that the result was probably actor Alan Rickman's (Snape) worst fear. When asked what Snape might have thought of the transformation, Rickman answered: "Snape isn't one who enjoys jokes—I strongly fear that his sense of humor is extremely limited."

TOP: Defense Against the Dark Arts Professor Remus Lupin houses a Boggart in an Art Nouveau–style cabinet for his lesson on *Riddikulus* in *Harry Potter and the Prisoner of Azkaban*
LEFT: The Boggart version of Neville Longbottom's worst fear: Professor Snape (Alan Rickman) dressed in his gran's clothes

44. MARAUDER'S MAP

When Harry Potter is unable to get a signature on a permission form allowing students to visit Hogsmeade, he employs his Invisibility Cloak, leaving very visible footprints in the snow that are seen by Fred and George Weasley. The twins appreciate his effort and gift him with the Marauder's Map.

The creation of the Marauder's Map by the graphics department started with what the designers did *not* want. "We didn't want it to be a *Treasure Island*, burned edges, whimsical in that sense piece," says Miraphora Mina. The map had been created by four Hogwarts students. "These four characters were very cunning and intelligent and crafty in what they were doing with this map," she explains. The team was inspired by the castle's moving staircases. They also wanted the map to have a three-dimensional form to suggest that every time it was unfolded, it would show another layer of the school—with the idea there could always be another layer that hadn't yet been discovered.

BEHIND THE MAGIC

The actual architectural drawings of the Hogwarts sets were traced over to create the map, which led to a mistake: the Room of Requirement was included on its initial drafts until someone finally noticed, and the room was covered over.

TOP: The folded Marauder's Map created by graphic artists Miraphora Mina and Eduardo Lima for *Harry Potter and the Prisoner of Azkaban*
ABOVE AND INSET: While studying the Marauder's Map in his dormitory, Harry (Daniel Radcliffe) is surprised to discover the supposedly deceased Peter Pettigrew is somewhere in Hogwarts
OPPOSITE TOP: Professor Remus Lupin (David Thewlis), aka "Moony," one of the original creators of the Marauder's Map
OPPOSITE BOTTOM: One of the many layers of the Marauder's Map, based on the practical blueprints for Hogwarts Castle

> **"Messrs. Moony, Wormtail, Padfoot and Prongs are proud to present The Marauder's Map."**
>
> —HARRY POTTER, *HARRY POTTER AND THE PRISONER OF AZKABAN*

While researching typefaces for the map, Miraphora Mina discovered eighteenth-century drawings of animals that were made up of words. This inspired the designers to forego using lines for the map's walls and borders, but used Latin words. A specific font was invented by Mina so that the map could be easily reprinted whenever additions were required. Runic symbols appear in places without any rhyme or reason, which, Mina says, "was frequently a type of visual shorthand for us to make things looks interesting." If the map was opened in an unfolded form (which is never seen), it would reach nearly six feet in length.

100 OBJECTS

82

45. HARRY'S WAND

In the wizarding world, wands are used to channel magic to offer the most accurate result when casting a spell, jinx, or charm. As designs came together for *Harry Potter and the Sorcerer's Stone*, "We wanted the wands to portray the wand bearer's personality in a way," says Stuart Craig. "So, we made Harry's relatively simple—not too fancy, but sturdy and powerful-looking." It took a few tries before the props department came up with the first wands for the films. "They were originally designed more like a magician's wand," says Craig, "with the white tip at the end. But J. K. Rowling set us straight almost immediately." Rowling described wands as "just like an old stick," says art director Hattie Storey, and so the earliest wands were a simple baton-style without much embellishment.

When Harry's wand chooses him, "We didn't use digital effects," says director Chris Columbus. "We wanted to create this magical moment and the feeling of the wand's power. We slowed down the film speed, blew some wind through Daniel's hair, and dimmed the lighting. It worked beautifully and created a sense of actually being there."

Harry Potter and the Prisoner of Azkaban director Alfonso Cuarón wanted the actors to have wands more suited to their personalities. Daniel Radcliffe chose a new wand with a handle that showcased its outer bark, appearing as if it had been whittled from a single root or branch. "The top was cast from a tree burr," explains prop modeler Pierre Bohanna. "This gives it a lot more character in, essentially, a very small piece of wood." The "bark" is a sculpted interpretation, but the hewing was done on a real piece of wood.

BEHIND THE MAGIC

Daniel Radcliffe admits that he had the habit of using his wand to drum on his legs. "Once every three or four weeks, it would weaken to the point where it just snapped," says Radcliffe. "So, I would say I was very sorry to the prop master, and he would give me a look like, 'Please stop drumming.'" Radcliffe broke somewhere between sixty to eighty wands over the course of filming.

> "Well, give it a wave."
> —GARRICK OLLIVANDER,
> *HARRY POTTER AND THE SORCERER'S STONE*

BEHIND THE MAGIC

The interior pages of *The Monster Book of Monsters* contain a block of pages featuring trolls, Cornish pixies, and goblins. These visuals were created by concept artist Rob Bliss, who also included plant creatures, four-limbed snakes, and a cross between a troll and a chicken.

47. THE MONSTER BOOK OF MONSTERS

In Harry's third year at Hogwarts, Rubeus Hagrid is named the new Care of Magical Creatures professor. Hagrid assigns *The Monster Book of Monsters* for the class curriculum, which proves to be the class's first challenge: unknown to most students, the only way to open it is to stroke the spine.

Miraphora Mina put together several concepts for the book, including one with clawed feet and another with a tail. One version of the book had a spine made up of spines. The book would have eyes, the number and placement of which changed frequently, along with fur, snaggly teeth, and tentacles. Its eyes went from the middle of the cover to nearer the spine and then back again to the middle, with the final number being four. The teeth were placed over the book's opening, guarding the very pages the students would need to read. Similar to the Howler, Mina ingeniously used the book's ribbon as its tongue. She also designed the typeface for the title and chose the author: Edwardus Limus, a play on her fellow graphics designer Eduardo Lima.

Three mechanical versions of the book were created for its various purposes. One was made to be held in the students' hands with moving tentacles, another had a snapping mouth that spewed out shredded paper. Harry Potter first attempts to open *The Monster Book of Monsters* while he is staying at the Leaky Cauldron before school starts and it leaps out of his hand, runs around the room, and hides under the bed. The third iteration moved around the room by virtue of a blue-screen pole that was removed in postproduction.

> "Now, open yer books to page forty-nine."
>
> "Exactly how do we do that?"
>
> "Just stroke the spine, of course! Goodness!"
>
> —RUBEUS HAGRID AND DRACO MALFOY,
> *HARRY POTTER AND THE PRISONER OF AZKABAN*

THESE PAGES: Concept art of *The Monster Book of Monsters* by (OPPOSITE) Adam Brockbank, (TOP) unknown, and (ABOVE) Miraphora Mina
LEFT: Harry (Daniel Radcliffe) tries to open his copy of *The Monster Book of Monsters* in his room at the Leaky Cauldron whereupon it jumps out of his hands

48. SNEAKOSCOPE

Harry is unable to visit Hogsmeade with the rest of the third years in *Harry Potter and the Prisoner of Azkaban*. In a scene deleted from the film, Ron and Hermione try to comfort their friend after their return with a gift from the Dervish and Banges shop: a pocket Sneakoscope.

A Sneakoscope is one version of a Dark Detector, devices created to alert the owner of any Dark magic or Dark wizards that could threaten them. The Sneakoscope in this pocket version looks like a glass toy top. Concept artist Dermot Power drew several different designs for the Sneakoscope with metallic or colorful finishes. He also incorporated suggestions for its ability to alert its owner of Dark forces nearby, by lighting up, spinning like the top it resembles, or whistling through holes on its sides.

BEHIND THE MAGIC

On the box for the Sneakoscope sold in Weasleys' Wizard Wheezes in *Harry Potter and the Half-Blood Prince*, the graphic artists list how the device works: through "Dermot Power," named after a concept artist who has worked extensively in the wizarding world and drafted a dozen ideas for the Sneakoscope.

TOP: The pocket Sneakoscope prop created for *Harry Potter and the Prisoner of Azkaban*
ABOVE: When Harry (Daniel Radcliffe) cannot go on a field trip to Hogsmeade, Ron (Rupert Grint), next to Hermione (Emma Watson), brings him a Sneakoscope from the Dervish and Banges shop
RIGHT: Various iterations of the Sneakoscope by concept artist Dermot Power
OPPOSITE TOP: The Time-Turner prop and its double-length chain
OPPOSITE MIDDLE AND BOTTOM: Hermione (Emma Watson) utilizes her Time-Turner to take her and Harry (Daniel Radcliffe) back in time to save Sirius Black and the Hippogriff Buckbeak

49. HERMIONE GRANGER'S TIME-TURNER

Hermione Granger is lent a Time-Turner in *Harry Potter and the Prisoner of Azkaban*, which allows her to take more classes than the day's schedule would normally allow.

When Miraphora Mina was briefed about creating the Time-Turner, she knew she wanted to combine the beauty of jewelry with the functionality of a scientific instrument. She began by researching clocks and astrological instruments, and was particularly taken by a collapsible astrolabe in Dumbledore's office, as the Time-Turner needed to be hidden on a chain by Hermione before she used it. "I came up with a shape that is a ring within a ring that could lie flat. But I definitely wanted some moving element to be a part of it," says Mina, who was also inspired by gyroscopes. "So it's really a ring within a ring that opens up and spins." The hourglass inside the piece is filled with real sand.

After Sirius Black is found and imprisoned in Hogwarts, Hermione and Harry use the Time-Turner to save him and Buckbeak, Hagrid's Hippogriff, who has been unjustly sentenced to death. "The script described an action where Hermione extends the chain to circle her and Harry," Mina says. "Normally, it wouldn't hang really long around her neck, but it was created with a double catch that allowed the chain to widen to fit around them both."

> Production designer Stuart Craig admits, "It took a lot of work to make [the Time-Turner] spin correctly. It actually probably would have helped to have one of them to use while we were making it."

> "Don't be silly, Ronald. How could anyone be in two classes at once?"
> —HERMIONE GRANGER, *HARRY POTTER AND THE PRISONER OF AZKABAN*

HARRY POTTER AND THE
GOBLET OF FIRE

50. PORTKEY

A Portkey is one of the many magical ways wizards move from place to place. Portkeys can be any inanimate object enchanted to transport someone who touches it to a predetermined location.

Arthur, Fred, George, Ron, and Ginny Weasley; Amos and Cedric Diggory; and Hermione and Harry use a Portkey in the form of boot to send them to the 422nd Quidditch World Cup. The prop team bought a new pair of boots, then wore them for weeks around the studio to "break them down" and give them the level of wear in order to suggest a "manky old boot" that had been laying in the field for a time.

In Barty Crouch Jr.'s final deception to get Harry to the Little Hangleton Graveyard, he enchanted the Triwizard Cup into a Portkey. When Harry and his fellow Hogwarts champion, Cedric Diggory, come upon the cup at the same time, they decide to share their victory together and simultaneously grab it. The version of the Triwizard Cup that sends Harry and Cedric to Little Hangleton was made from rubber, as it needed to fly out of their hands and bounce on the ground but not break.

> "It's a Portkey. Harry, the cup is a Portkey."
> —CEDRIC DIGGORY, *HARRY POTTER AND THE GOBLET OF FIRE*

Actress Bonnie Wright (Ginny) mostly enjoyed doing her own stunts for the films, but found the spinning for the Portkey movements scary at the start. Eventually, she got used to it and could relax into it for the stunt.

TOP: The manky old boot used as a Portkey for transport to the 422nd Quidditch World Cup
LEFT: Hermione (Emma Watson), Fred Weasley (James Phelps), Arthur Weasley (Mark Williams), George Weasley (Oliver Phelps), and Ron Weasley (Rupert Grint) en route to the Portkey that will take them to the Quidditch World Cup grounds
OPPOSITE LEFT: Miranda Richardson as Rita Skeeter, writer for the *Daily Prophet*, during the first task of the Triwizard Tournament
OPPOSITE RIGHT: Rita Skeeter's notes from her interview with Harry Potter, written by the graphics department and her Quick-Quotes Quill

51. RITA SKEETER'S QUICK-QUOTES QUILL

Once the Triwizard champions are selected, they are ushered into the trophy room to pose for pictures and be interviewed by Rita Skeeter of the *Daily Prophet*. Skeeter has a reputation for tabloid-style journalism, encouraged by the use of a Quick-Quotes Quill. This writing instrument appears to reinterpret what has been said to the reporter's writing style.

"She uses [the quill] when she's trying to inveigle her way into somebody's sympathies," says actress Miranda Richardson. "That means she has her hands free, and all her concentration can be on the person in front of her, which, for the tournament, is mostly Harry." Richardson believes her character works to get honest reactions from what she calls "her prey," she continues, "and she's already writing what she thinks the public wants to hear."

The Quick-Quotes Quill is a combination of special and visual effects, and its quill was a major component of both applications. "We got literally hundreds and hundreds of quills from this one company throughout the course of the films," says prop master Barry Wilkinson. "For Rita Skeeter's, we just picked out some of the longest and finest ones."

Her first interview, with Harry, takes place in a broom cupboard. Harry watches as the quill writes on a floating pad, making quick corrections and edits that feel almost telepathically received from Skeeter. Richardson even assumed that the quill writes what she's thinking "like a transferred thought." As the quill "wrote down" the interview, a radio-controlled magnetic quill was maneuvered through an unseen channel built into the tablet.

> "I'm Rita Skeeter. I write for the *Daily Prophet*. But of course you know that, don't you?"
>
> —RITA SKEETER, *HARRY POTTER AND THE GOBLET OF FIRE*

52. TRIWIZARD CUP

The victor of the Triwizard Tournament claims the Triwizard Cup for his school. For a connecting throughline to the Goblet of Fire, Miraphora Mina researched medieval relics and chalices for inspiration for the Triwizard Cup. Noting the frequency that dragons appeared on these, she designed the cup's three handles as dragons to give a nod to the three participating schools, as well as to the first task of the tournament.

Pierre Bohanna asserts that even from the concept stage, the cup gave him a very strong impression of what the metalwork should be. "We wanted to get that strange blue-gray coloring; we didn't want it to be a silver. We didn't want it to be high-finished. We wanted it to look like a very old piece, a weighty casting, and you wouldn't get that with a silver finish." The cup was cast in pewter, which was a popular material in the Middle Ages. Its darkness and matte finish spoke to the antiquity of the piece.

Like the Goblet of Fire, the Triwizard Cup is also considered a living organism, with the prop makers suggesting this by mosslike tendrils "growing" within its crystal sides. "There are stylized flames and fernlike details inside the crystal that I consider are growing all the time," says Mina. To create this effect, Bohanna blended different chemicals that counteracted each other, causing a fractured and cracked appearance. He also added a special ingredient to the blend. "Tiny confetti-size chips of plastic cling wrap were thrown into the process, which cause the chemicals to pull away from one another," he explains. The idea came to him as he was researching natural materials that had cracks and crinkles. "We wanted the folds and the character within it," he states. "Nature always has the answer."

The Triwizard Cup needed to be made in different materials for its different pieces. To accomplish this, the parts of the cup were molded individually. Some cups were cast in resin or metal, and others were made with latex and rubber.

> "Only one will hoist this chalice of champions, this vessel of victory, the Triwizard Cup!"
>
> —ALBUS DUMBLEDORE,
> *HARRY POTTER AND THE GOBLET OF FIRE*

BEHIND THE MAGIC

The glass of the cup was given a blue-green cast that hints at the second task, which takes place underwater. The light that comes from within is not completely a visual effect. "We put an actual light in it in order to make it glow," says property master Barry Wilkinson. "Then that was enhanced later on."

53. GOBLET OF FIRE

The Triwizard Tournament is a competition between the three largest wizarding schools in Europe: Hogwarts School of Witchcraft and Wizardry, Beauxbatons Academy of Magic, and Durmstrang Institute. Names are placed in the Goblet of Fire, which will later spit out the champions selected to participate.

The Goblet of Fire is brought out into the Great Hall in a bejeweled casket, which has the air of a religious reliquary, designed by Miraphora Mina. Production designer Stuart Craig and Mina researched medieval architecture as well as that of English and Russian Orthodox churches. Then the casket melts away to reveal the Goblet itself. Mina always appreciated the idea of discovery and having to look for things hidden within before being revealed. "It's always more interesting to have that, isn't it?" she says. She had hoped this could be achieved in a practical effect, but it was decided to have it done digitally. "But the casket is a real physical object, no doubt," Mina affirms. "I had to carry it into the Great Hall."

> "Anyone wishing to submit themselves for the tournament merely write their name upon a piece of parchment and throw it in the flame."
>
> —ALBUS DUMBLEDORE, *HARRY POTTER AND THE GOBLET OF FIRE*

The designers were unsure how big the Goblet of Fire needed to be, and so Stuart Craig's original concept for it was for it to be a small, metal cup encrusted with jewels. But as their research continued, the Goblet became "a huge Gothic cup decorated with a Gothic motif that's been created from wood," Craig explains. "We found the best bit of timber we possibly could, with burrs and twists and knots and splits in it." This gave the Goblet a special quality—even though it's incredibly ancient, it is at the same time organic. Miraphora Mina asserts that perhaps although the Goblet has been sculpted, "you weren't sure whether it had finished growing."

A second version of the Goblet of Fire was cast out of the original mold and rigged to spit out the pieces of parchment with the champions' names by the special effects team.

The prop makers sculpted the five-foot-tall artifact out of an English elm tree trunk, supplemented by some plastic castings. At the midpoint of the Goblet, a carved Gothic-style building peeks out from woody knobs that perhaps are covering it over as the tree continues to grow.

OPPOSITE TOP: The Triwizard Cup
OPPOSITE FAR LEFT: The Triwizard Cup in the third task's maze turns out to be a Portkey
OPPOSITE RIGHT: Visual development sketches of the Triwizard Cup
TOP: The Goblet of Fire prop, carved from a single piece of oak
ABOVE: Bartemius Crouch Sr. (Roger Lloyd-Pack) and Albus Dumbledore (Michael Gambon) beside the casket that holds the Goblet of Fire in *Harry Potter and the Goblet of Fire*

54. TRIWIZARD TOURNAMENT WELCOME FEAST FOOD

There have been many feasts held in the Great Hall of Hogwarts over the years featuring hot and hearty dishes. For the Welcome Feast for the students from Beauxbatons and Durmstrang who join those at Hogwarts for the Triwizard Tournament, set decorator Stephenie McMillan wanted to try something new: a dessert feast. "I thought this would please the children, because they'd seen boring joints of turkey and roast beef too often. And, well, I know our art department's full of chocoholics."

Three colors were originally chosen for the feast's palette: dark chocolate, milk chocolate, and white chocolate. After reviewing the overall tone, director Mike Newell asked McMillan to include other colors to break up all the brown. "So, we used a delicate pink tint in the Hogwarts jugs, and put a few pink sweets in as well."

Ideas for the desserts came from various "Hogwarty" inspirations, as McMillan described it. Shiny chocolate cakes topped with chocolate frogs nodded to Honeydukes. Stacked pumpkin-shaped cakes were molded from the prop pumpkins in Hagrid's garden. Chocolate rabbits leaping out of chocolate top hats were a reference to Muggle magic. These were so admired that instead of making sixteen that were planned, they ended up making sixty-four of them. McMillan had planned a series of cakes inspired by the four houses of Hogwarts to be set on the headmaster's high table, but when that became overly complicated, the designers went with phoenix-adorned cakes set near Dumbledore that represented his phoenix, Fawkes. "We had giant wobbling chocolate trifles, blancmanges, steamed sponge puddings, which are not the prettiest things, and jelly custards, which Newell requested," said McMillan. "And a magnificent ribbon cake that, if you cut it, would have a most delicious, heavy, chocolatey filling made with rum inside. Well, I dreamed it would, anyway!" Multiples of the baked goods were required for the scene that ran into the hundreds.

> "As from this moment, the Triwizard Tournament has begun."
> —ALBUS DUMBLEDORE,
> *HARRY POTTER AND THE GOBLET OF FIRE*

TOP: Chocolate cake based on the Muggle magic trick of pulling a rabbit out of a hat. The hat was made from a mold; the rabbits were not.
BOTTOM: Clémence Poésy as Fleur Delacour, the Beauxbatons champion
OPPOSITE TOP LEFT: Albus Dumbledore (Michael Gambon) casts a charm to reveal the Goblet of Fire in *Harry Potter and the Goblet of Fire*
OPPOSITE TOP RIGHT AND BOTTOM LEFT: Chocolate cakes and confections for the first dessert feast seen at Hogwarts, rendered in faux versions of light, dark, and milk chocolate
OPPOSITE BOTTOM RIGHT: The arrival of who will become the Durmstrang champion, Viktor Krum (Stanislav Ianevski), flanked by headmaster Igor Karkaroff (Predrag Bjelac, right) and his aide (Tolga Safer, left)

More than one thousand tiny white chocolate mice (and an odd pink one or two) ran along the tables. At least they started with one thousand mice, knowing that the actors might eat more than a few of them.

OPPOSITE: One thousand white (and a few pink) chocolate mice wound around other confections on the Great Hall tables at the dessert feast in *Harry Potter and the Goblet of Fire*
ABOVE: A stack of chocolate pumpkin cakes and a profiterole "explosion" were only a few of the many desserts served at the feast

ABOVE: Roughly one hundred silver megaphones provided the background when the students (and a few professors) rocked out at the end of the Yule Ball
OPPOSITE: The Great Hall was transformed by production designer Stuart Craig and set decorator Stephenie McMillan into an ice palace, covered in silver fabrics from floor to ceiling

GOBLET OF FIRE

ABOVE AND BOTTOM: Closed and open forms of the Golden Egg prop, a clue to the second task of the Triwizard Tournament in *Harry Potter and the Goblet of Fire*

RIGHT: Harry Potter (Daniel Radcliffe) is given a clue from Cedric Diggory to take the egg to the seventh floor prefects' bathroom and "mull things over in the hot water"

OPPOSITE TOP: The Golden Egg, designed by graphic artist Miraphora Mina

OPPOSITE BOTTOM: Hermione (Emma Watson) worries when Harry (Daniel Radcliffe) cannot figure out how to translate the screeches made by the opened Golden Egg

57. GOLDEN EGG

For the first task of the Triwizard Tournament, the champions must retrieve a large golden egg protected by a dragon, for the egg contains a clue to the second task. The four champions succeed at collecting their prize, but when opened, the egg emits an excruciating screech. So, the next "task" becomes how to translate the clue inside.

Designer Miraphora Mina liked to incorporate the idea of discovery in the props she designed, and so knew it would need to be more than just "cracking" the egg. "It needed to be something that would only open when you had the right 'code,'" she explains. Mina was inspired by the mechanical Easter eggs produced for the Russian royal family, and chocolate oranges, whose slices separate when the sweet is banged on a specific spot. When an owl's head atop the gold-plated egg is turned, its three sides open to reveal a mysterious crystal-like structure.

Clear, round crystals were mixed with liquid resin that created a "watery" effect for the structure inside, linking the egg to the second task, which takes place under the waters of the Black Lake. Mina appreciated the correlation. "It seems a natural kind of visual connection between the two. It looks as though [the egg's] actually alive inside in a way."

> "Your objective is simple: collect the egg. This you must do, for each egg contains a clue without which you cannot hope to proceed to the next task."
> —BARTEMIUS CROUCH SR., *HARRY POTTER AND THE GOBLET OF FIRE*

Because Harry unlocks the clue in the tub in the prefects' bathroom, the golden egg had to be designed to be totally waterproof.

58. PENSIEVE

Stored in the office of the Hogwarts Headmaster is a Pensieve, which allows the user to view memories—theirs or others. In *Harry Potter and the Goblet of Fire*, Harry accidentally "falls" into the Pensieve's shallow waters and views a memory of the Death Eater trials after the first wizarding war.

The Pensieve seen in *Goblet of Fire* was set into a stone goblet-shaped table within the cabinet. The memories that swirled in the Pensieve were of a digital construction, with its watery surface producing swirls of waves and Harry's reflection that dissolve into the memory, pulling Harry in with it.

> "Curiosity's not a sin, Harry, but you should exercise caution. It's a Pensieve. Very useful if, like me, you find your mind a wee bit stretched. It allows me to see once more things I've already seen."
>
> —ALBUS DUMBLEDORE, *HARRY POTTER AND THE GOBLET OF FIRE*

In *Harry Potter and the Half-Blood Prince*, Dumbledore persuades former Potions Professor Horace Slughorn to return to Hogwarts so he can view a memory about Tom Riddle and his pursuit of Horcruxes. Now, a shallow, parabolic dish rises off the tabletop and suspends itself in midair. Once "activated" by the memory poured into it, the surface becomes a swirling cloud shape with strands of falling ink. Once the viewer's face is immersed in the water, inky black threads descend and solidify into the memory. The digital artists also added live-action film of ink dropping into an aquarium to embellish the effect.

Severus Snape begs Harry to take his tears before he dies in *Harry Potter and the Deathly Hallows – Part 2* and view his memories for knowledge Harry needs to defeat Voldemort. For this iteration, Harry removes the bowl from the Pensieve on its tabletop and sends it flying across Dumbledore's office until it sets itself down on the deceased headmaster's desk. As Snape has provided a series of memories, the different scenes are separated by the inky strands.

TOP RIGHT: Design for the stand the Pensieve rests upon in *Harry Potter and the Half-Blood Prince*
TOP: Dumbledore (Michael Gambon) retrieves a memory to place in the Pensieve
ABOVE: Michael Gambon (Dumbledore) and Daniel Radcliffe (Harry) film with the Pensieve. A physical prop with VFX reference points marked upon it would later be utilized by the visual effects crew to render the Pensieve in postproduction.
OPPOSITE: Harry submerges his face in the Pensieve to view Dumbledore's memory of his first meeting with Tom Riddle. Artwork by Rob Bliss.

Director David Yates desired a simpler design for the Pensieve in *Harry Potter and the Half-Blood Prince*, wanting more emphasis on the "revelation" of the memory.

The cylindrical memory cabinets complemented the design of Dumbledore's office, which was a set of three circles that cantilevered off a circular tower.

59. PENSIEVE MEMORY BOTTLES

Dumbledore keeps the vials of memories he has collected for use in his Pensieve in tall, Gothic-style glass cabinets. These memory cabinets are filled with hundreds of tiny glass vials that contain the memories of professors, headmasters, seers, traitors, and Dark wizards, among others.

Miraphora Mina designed the labels for the memory bottles with the idea of expressing the transitory and prized nature of the content they held, giving them a delicate, ethereal appearance. There is much less information on them compared to potions bottles, as she only needed to offer ideas that would, ironically, stimulate Dumbledore's memory as to what they contained.

Mina was inspired by Victorian architectural details for the ornamental decorations around the labels, called "frets." Once the design was in place, the labels were handed off to the prop makers to be laser cut, then handwritten and aged. Each vial had its own individual label stuck on by hand.

The construction of the memory vials was similar to the smallest potion bottles, crafted by supervising modeler Pierre Bohanna. The prop maker bought test tubes and then cast the bottle on the top to create different interesting looks for the tops and bottoms. There were somewhere between eight and nine hundred vials placed very carefully into the cabinet and then lit from within and without.

> "This is perhaps the most important memory I've collected. It's also a lie. This memory has been tampered with. In this case by the person whose memory it is, our friend Professor Slughorn."
>
> —ALBUS DUMBLEDORE,
> *HARRY POTTER AND THE HALF-BLOOD PRINCE*

BEHIND THE MAGIC

The transitory but precious nature of each memory's contents was conveyed through the delicate appearance of the tiny vials.

OPPOSITE: Roughly nine hundred memory vials were created in a collaboration between the props and graphics department, each label lettered, aged, and placed on by hand
TOP: Vial containing Tom Riddle's altered memory of the creation of Horcruxes, unknowingly taught to him by Horace Slughorn, as seen in *Harry Potter and the Half-Blood Prince*
ABOVE: Harry (Daniel Radcliffe) prepares to watch a memory given to him by Severus Snape in *Harry Potter and the Deathly Hallows – Part 2*
LEFT: One of many test tubes used by the props department to create the small memory vials

60. LITTLE HANGLETON GRAVEYARD STATUE

When Harry Potter and Cedric Diggory grab the Triwizard Cup to share victory in the Triwizard Tournament, the cup acts as a Portkey and transports them to Little Hangleton Graveyard, the burial ground of the Riddle family.

Little Hangleton Graveyard, one of the biggest sets constructed for the films, sits on a hill top scattered with gravestones and statues. Production designer Stuart Craig assumed the graveyard had been there for generations, and so fixed on creating an ancient feeling to it. "Essentially, it is about decay and dereliction," says Craig. He was inspired by Highgate Cemetery in North London, built in 1839, "which had, in a way, been reclaimed by nature," he explains. Little Hangleton's cemetery has been allowed to become overgrown with vines and shrubs, and its gravestones are crumbling. The ground was covered with living grass, and the set was crowded with huge, moss-covered tombstones, some of which bore the names of crewmembers' pets.

The statue above the Riddle family tomb, sculpted by Bryn Court, was originally conceived to be an angel, but a beautiful one, inspired by heavenly monuments in Highgate. The idea changed for the statue to become an "Angel of Death"—a winged version of the Grim Reaper—when the filmmakers realized how much more appropriate it would be to the family buried there.

The Riddles' tomb was sculpted before the filmmakers knew Voldemort's ancestry, and so the dates on the plaque were changed in postproduction.

> "Harry. I'd almost forgotten you were here, standing on the bones of my father."
>
> —VOLDEMORT,
> *HARRY POTTER AND THE GOBLET OF FIRE*

61. ALASTOR MOODY'S TRUNK

A devious plan is devised by Death Eater Barty Crouch Jr., to have Harry become a champion in the Triwizard Tournament. Barty uses Polyjuice Potion to transform himself in the fourth-year's new Defense Against the Dark Arts professor: Alastor "Mad-Eye" Moody. Crouch has placed the real Moody—without his magical eye and prosthetic leg—in a locked trunk in his office.

The seven-level multi-lock trunk was a fully working prop created by the special effects department. Each tier of the trunk would unlock and raise mechanically to reveal the level above it when activated.

> "You all right, Alastor?"
>
> "Yes, sorry, Albus."
>
> —ALBUS DUMBLEDORE AND ALASTOR MOODY,
> *HARRY POTTER AND THE GOBLET OF FIRE*

"He's one of those people who what you see is what you get," says actor Brendan Gleeson of his character in *Goblet of Fire*. "Then, of course, what you see is *not* what you get with Moody." Ironically, the ex-Auror was brought to Hogwarts to protect Harry, and Barty Crouch does the same, but only to ensure the youngest champion can get to the end of the competition and win. Though Gleeson plays a character within a character, he found similarities in their personas: both are paranoid and no-nonsense, so perhaps that's why those who knew Moody didn't notice any abrupt change in his personality.

BEHIND THE MAGIC

Brendan Gleeson considers Alastor Moody and Harry Potter to be kindred spirits. "He understands that in the way Harry's been maligned for being suspicious or telling lies, Moody has had the same kind of experience."

OPPOSITE TOP: The Angel of Death statue at Leavesden Studios before being placed into the Little Hangleton Graveyard set
OPPOSITE MIDDLE: Harry (Daniel Radcliffe) is trapped by Voldemort in the arms of the Angel of Death statue to become part of a ritual to restore the Dark wizard to corporeality
TOP: The seven-tiered trunk created to hide the real Alastor Moody
LEFT: Artwork by Rob Bliss of the trunk Barty Crouch Jr. uses to imprison Alastor Moody, which was realized in a working mechanical prop

HARRY POTTER AND THE
ORDER OF THE PHOENIX

62. MINISTRY OF MAGIC DOCUMENTS

The wizarding world's Ministry of Magic abounds with flying memos, notebooks and folders, visitor badges, and identity cards. The graphics department was tasked with creating letters for disciplinary hearings and registration forms when the Muggle-Born Registration Commission was created. There are door plaques, reference information for filing purposes, and layers and layers of seals and stamps that must be applied in duplicate and triplicate to the never-ending documents.

> "If found, please return by owl to the Ministry of Magic."
> —REVERSE OF MINISTRY OF MAGIC IDENTITY CARDS

THESE PAGES: Documents and other ephemera created for the Ministry by the graphics department include (clockwise from top) a door plaque from the Ministry Trial Chamber seen in *Harry Potter and the Order of the Phoenix* and *Harry Potter and the Deathly Hallows – Part 1*; flying memos created for *Harry Potter and the Order of the Phoenix*; Ministry letter to Harry for his violation of the decree for underage sorcery and a letter to Arthur Weasley for the same as Harry's guardian; Ministry identity card for Reg Cattermole seen in *Harry Potter and the Deathly Hallows – Part 1*; and even more Ministry paraphernalia created by the graphics department for *Harry Potter and the Deathly Hallows – Part 1*

Miraphora Mina and Eduardo Lima wanted the Ministry of Magic's logo, embossed on every document, to be recognizable at a glance. A simple capital letter *M* was chosen, with an illuminated wand that runs down the central spine. Additional logos for different departments and organizations were created, such as the Ministerial Wizarding Registration Department (or MWRD) and the Ministry of Magic Wizarding Union.

The official color of the Ministry, purple, was used for the flying memos and letterheads, right down to the fingerprints on the identity cards. The identity cards were also created with the pertinent information of height, weight, and signature, and stamped with the Ministry logo in purple ink. When filmed, green-screen paper was a placeholder on the IDs for moving pictures placed in digitally in postproduction.

When Dolores Umbridge returns to the Ministry for the events in *Harry Potter and the Deathly Hallows – Parts 1 and 2*, she becomes head of the Muggle-Born Registration Commission, which distributes propaganda against non-pure-bloods in the form of decrees and pamphlets, such as *Mudbloods and How to Spot Them*. The graphics department employed a typeface similar to the Russian constructivist typography with bold, block letters that was used in the *Daily Prophet* upon Voldemort's rise to power. These are also official Ministry of Magic publications, but this paperwork is printed in eye-catching bright reds and pinks, which are Umbridge's preferred colors.

The graphics department created a stamp for inking official documents, so it is clear they are "Certified by the Ministry of Magic."

Luna proves to not only be supportive of Harry, but also an empathetic and nonjudgmental friend. "Luna is wise," says Lynch. "She grounds him and calms him. And I think he helps her just by being her friend."

KEEP OFF THE DIRIGIBLE PLUMS

63. LUNA LOVEGOOD'S DIRIGIBLE PLUM EARRINGS

Luna Lovegood is introduced at the beginning of Harry's fifth year at Hogwarts, on a cart being pulled by Thestrals to Hogwarts. In addition to her Butterbeer necklace, Luna Lovegood also wears a pair of earrings that resemble Dirigible Plums: an orange-colored fruit that grows upside down. A bush of these gravity-defying fruits surrounds the Lovegood house, fronted by a large sign that cautions visitors to keep off them.

Dirigible Plums actually resemble radishes, and when a pair of red, radish-shaped earrings was commissioned by costume designer Jany Temime, they were quickly corrected by actress Evanna Lynch. "Evanna said, 'No, they're supposed to be orange,'" says costume designer Jany Temime. "That's how well she knew the character. The earrings you see Evanna wearing in the film are actually made by her and yes, they're orange."

Over the course of the films, Lynch also made the beaded Hare Patronus bracelet her character wears to the Slug Club Christmas Party in *Harry Potter and the Half-Blood Prince*, in addition to offering design ideas for the roaring lion hat Luna wears to support her friends on the Gryffindor Quidditch team. "I wanted it to look like it was eating her head," she explains.

"Keep Off The Dirigible Plums"
—SIGN OUTSIDE THE LOVEGOOD HOUSE,
HARRY POTTER AND THE DEATHLY HALLOWS – PART 1

OPPOSITE TOP: Luna Lovegood (Evanna Lynch) wearing her Dirigible Plum earrings in *Harry Potter and the Order of the Phoenix* (right) and *Harry Potter and the Deathly Hallows – Part 2* (left)
OPPOSITE BOTTOM: Director David Yates talks with Rhys Ifans (Xenophilius Lovegood), careful to stay off the Dirigible Plum plants that grow outside the Lovegood home
RIGHT: Evanna Lynch as Luna Lovegood in a publicity still for *Harry Potter and the Order of the Phoenix*

64. THE QUIBBLER MAGAZINE

As the masthead of *The Quibbler* magazine proclaims, it is "The Wizarding World's Alternative Voice." *The Quibbler* is edited by Xenophilius Lovegood, and so the graphics department knew that the magazine needed to be as quirky and eccentric as its publisher.

To emphasize its tabloid-style approach, *The Quibbler* was printed on thin newsprint paper, and did not make use of moving photographs as did the *Daily Prophet,* but relied on bright colors and cartoonlike graphics, with a glossy shine on its covers.

The Quibbler publishes a wide variety of topics in addition to its political views, with material supplemented by the graphics team. Some address current events—"Potter Defies Ministry Intelligence Once Again!"—and others are based on conspiracy theories, such as "Goblins Baked in Pies!" Regular features include articles on sports, potions, and spells, and a weekly "Muggle World" column, with articles such as "Fax Machine: What's the Point?"

A special edition of *The Quibbler* was created with heavier material for its cover in *Harry Potter and the Half-Blood Prince,* as it held an insert perforated for removal with the Spectrespecs printed on it.

BEHIND THE MAGIC

Harry, Ron, and Hermione get a chance to see where *The Quibbler* is printed when they visit Xenophilius in *Harry Potter and the Deathly Hallows – Part 1.* Five thousand copies of the latest issue were printed to pile around Lovegood's circular house.

> "Quibbler? Quibbler?"
>
> —LUNA LOVEGOOD,
> HARRY POTTER AND THE HALF-BLOOD PRINCE

THESE PAGES: Various issues of *The Quibbler* feature articles on Yetti (sic) footprints and an ad for owl training.
ABOVE: Luna Lovegood (Evanna Lynch) is reading a copy of her father's publication (albeit upside down) when she meets Harry Potter in *Harry Potter and the Order of the Phoenix.*

THE QUIBBLER

FUNNY OLD WIZARDING WORLD

1. WRACKSPURTS BREAK OUT AT MINISTRY ELFIN SAFETY ENQUIRY

2. FAKE HENNA SCANDAL! GINGER WITCH SENT TO AZKABAN

LEFT IS THE NEW RIGHT

3. EXISTING WIZENGAMOT THEORIES LOSE CREDIBILITY

4. YETTI FOOTPRINTS! TRUE SIGHTING OR ANOTHER PRANK?

Moody's broom is crafted from a mahogany-colored wood. Its pedals are set at the front, which gives it the look of a chopper. The broom has a seat back that he leans on and handheld steering controls. The back of the seat can fold up for easy carrying.

65. ALASTOR MOODY'S BROOM

As each new character appeared in the Harry Potter films, the concept artists would try to design their broom to match their personality. Alastor "Mad-Eye" Moody, the Defense Against the Dark Arts professor in *Harry Potter and the Goblet of Fire* is an original member of the Order of the Phoenix, and a former Auror who has lost a leg and an eye in his pursuit of Dark wizards.

Moody's broom is as unique as its passenger. "If I remember this correctly," says concept artist Adam Brockbank, "I showed Stuart Craig a drawing of a kind of *Easy Rider* broomstick for Mad-Eye Moody, where he would sit on it with his legs forward, like a chopper." Craig refined the concept, passing the artwork between them several times before the final version was approved. "It was beautifully made, although you can't see much of it [in the film]," Brockbank adds. "But you can see by the way he sits in it that it's different from the others."

"I have the coolest broom in the cupboard," says actor Brendan Gleeson (Moody). "This is the broomstick of all broomsticks as far as I'm concerned." Gleeson admits that, at the best of times, he doesn't like heights, but he does love speed, and found filming the flying sequence to have all the fun of a fairground ride.

> "Half the cells in Azkaban are filled thanks to him."
>
> —RON WEASLEY,
> *HARRY POTTER AND THE GOBLET OF FIRE*

OPPOSITE: Close-up of the finely etched details on the collar of Alastor Moody's broom
TOP and LEFT: Visual development of Alastor Moody's broom by Adam Brockbank
ABOVE: Brendan Gleeson poses as Alastor Moody in a publicity still for *Harry Potter and the Order of the Phoenix*

66. BLACK FAMILY TAPESTRY

Harry stays at Number Twelve, Grimmauld Place, before and after his hearing for the use of underage magic. Once acquitted, he walks through the halls and comes upon a room displaying a wall-to-wall tapestry. Harry's godfather, Sirius Black, explains that this is the Black "family tree," pointing to the place where his face had been burned out of the fabric.

When the graphics department read the script for *Harry Potter and the Order of the Phoenix*, they were stumped by one item that would be seen in the family home of Sirius Black. "It said 'there is a family tree,'" says Miraphora Mina. "Our job as graphic designers was to present the whole thing, and we didn't know who was related to who."

For help in filling out the family tree, Miraphora Mina and Eduardo Lima went to producer David Heyman, who in turn asked author J. K. Rowling. "[Her] knowledge of the world of Harry Potter is so deep," says Heyman. "I told her we were going to show the Black family tree and asked, 'Do you have any thoughts?'" In a short amount of time, Rowling sent back a detailed document showing many generations of Blacks, complete with birth and death dates, and gaps for members who had been similarly disowned like Sirius.

> The Latin inscription that runs on the top and bottom translates as "The Noble and most Ancient House of Black."

ABOVE: Digital art of the room-size tapestry portraying the family tree of the Noble and Most Ancient House of Black
LEFT: Film stills of Harry (Daniel Radcliffe) with his godfather, Sirius Black (Gary Oldman) in the tapestry room; and an interruption by the Black family house-elf, Kreacher
OPPOSITE: A publicity still of Gary Oldman as Sirius Black in *Harry Potter and the Order of the Phoenix*

BEHIND THE MAGIC

Skulls were included in the tree to suggest that the family member had died young or were met with a violent death. Sirius's younger brother, Regulus, is represented by a skull.

ORDER OF THE PHOENIX

67. DARK ARTS DEFENSE: BASICS FOR BEGINNERS

New Defense Against the Dark Arts professor Dolores Umbridge comes to Hogwarts from the Ministry of Magic. The book she's assigned for the fifth-years—*Dark Arts Defense: Basics for Beginners*—will barely teach them defensive spells, for she worries Dumbledore is trying to turn the students against the Ministry.

> "There's nothing in here about using defensive spells?"
>
> "Using spells? I can't imagine why you would need to use spells in my classroom."
>
> —HERMIONE GRANGER AND DOLORES UMBRIDGE, *HARRY POTTER AND THE ORDER OF THE PHOENIX*

The graphic designers were inspired by children's books of the 1940s and 1950s. "They would have a cloth spine and a printed front," says Miraphora Mina. "They were seen very quickly on-screen, but needed to convey that the level of instruction had been reduced to almost a primary-school level." It was important to have artwork that could register a juvenile, almost patronizing, viewpoint. "It's a textbook for fifteen-year-olds that actually should be given to a seven-year-old," Mina adds. "And we went with a thick paper, so that there was basically no content to this thing."

The image on the cover is based on something called the "Droste effect," named after a nineteenth-century cocoa that advertised itself with a tin printed with the image of a nurse holding a box of cocoa with the image of a nurse holding a box of cocoa, which theoretically could go on forever. "These are children playing wizards," say Mina, "looking at a picture of themselves reading the book with a cover of them looking at a picture of themselves reading the book, in an endless spiral."

BEHIND THE MAGIC

Set decorator Stephenie McMillan did very little decoration to Umbridge's classroom. "We just thought that, as she doesn't teach, we're going to have the room completely empty, apart from the desks, her desk, and the blackboard, and just the books," said McMillan, "and they're not even proper textbooks."

68. DOLORES UMBRIDGE'S BLOOD INK QUILL

When Harry Potter and Professor Dolores Umbridge argue whether or not Voldemort has returned, she assigns him detention in her office. Harry will be doing lines—writing "I must not tell lies" on parchment prepared for him. She also hands him one of her quills, a very special one. As Harry begins to write, he sees the words appearing not on the paper, but on the back of his hand, as the quill spells out the words using the writer's blood.

"I felt terrible after that scene," says actress Imelda Staunton. "I thought it was horrible. And it's alarming that people think punishment is a way of teaching someone, and she believes that is true. It's unbelievable that a character can do what she does, like torturing Harry, but she feels she's doing good."

> "You're going to be doing some lines today for me, Mr. Potter. No, not with your quill. You're going to be using a rather special one of mine."
>
> —DOLORES UMBRIDGE,
> *HARRY POTTER AND THE ORDER OF THE PHOENIX*

Umbridge uses the punishment again in *Harry Potter and the Order of the Phoenix*, for students including Fred and George Weasley, who are defying her new decrees.

OPPOSITE TOP: Dolores Umbridge uses the slightly insulting book *Dark Arts Defence: Basics for Beginners* for Harry's fifth-year Defense Against the Dark Arts class
OPPOSITE BOTTOM: Instructional pages inside include children's book-style illustrations
TOP: Dolores Umbridge's Blood Ink Quill, created by the props department
ABOVE: When Harry uses the quill in detention, the assigned phrase "I must not tell lies" appears in blood on the back of his hand
RIGHT: Imelda Staunton as Professor Dolores Umbridge in *Harry Potter and the Order of the Phoenix*

PROCLAMATION.

EDUCATIONAL DECREE
☞ No. 119

DOLORES JANE UMBRIDGE HAS REPLACED ALBUS DUMBLEDORE AS HEAD OF HOGWARTS SCHOOL OF Witchcraft & WIZARDRY

As Referred to in Decree No. 157 of 1924, formerly known to be the Ministerial Management of Magical Mayhem Act No. 792/B & subject to Approval by The Very Important Members of Section M.ITrx

> "Ministry Seeks Educational Reform. New Era Dawns at Hogwarts."
>
> —THE *DAILY PROPHET* HEADLINE, *HARRY POTTER AND THE ORDER OF THE PHOENIX*

BEHIND THE MAGIC

Just before the Weasley twins, Fred and George, leave Hogwarts forever with a bang (literally), fireworks smash into every Educational Decree, exploding the framed documents. As Dolores Umbridge stands stunned at the event, the plaques suddenly fly off the wall and crash to the ground around her. Fortunately, these versions of the Decree were made of foam.

THESE PAGES: Educational Decrees written by Dolores Umbridge cancel Quidditch, confiscate broomsticks, and announce her takeover of Hogwarts from Albus Dumbledore
TOP: Hogwarts High Inquisitor and (temporary) Headmistress Dolores Umbridge (Imelda Staunton) peeks out from the Great Hall when she hears disturbing noises outside during O.W.L.s testing in *Harry Potter and the Order of the Phoenix*
OPPOSITE BOTTOM: Dolores Umbridge seeks refuge from an explosion of fireworks ignited by Fred and George Weasley in the Great Hall that ends in all the Educational Decrees shattering and covering her in debris

69. EDUCATIONAL DECREES

At Hogwarts, Dolores Umbridge lays down a series of Educational Decrees. Among the first is having the Ministry of Magic name her Hogwarts High Inquisitor. She continues having caretaker Argus Filch hang up proclamation after proclamation on the wall in front of the Great Hall.

Similar to the block style of lettering that the graphics department used for the *Daily Prophet* when the Ministry took over, bold graphics in simple shapes were used for the printing of the Decrees dictated by the script. However, other text written on the Ministry's "behalf" by Miraphora Mina and Eduardo Lima gave a bit of a sardonic nod to the silliness indicative in bureaucracy. After the Decree is declared, it is "As referred to in Decree No. 157 of 1924, formerly known to be the Ministerial Management of Magical Mayhem. Act No 792/B Subject to The Approval By The Very Important Members of Section M. I. Trx."

70. DOLORES UMBRIDGE'S CAT PLATES

Dolores Umbridge definitely exudes her own fashion style, from her fuzzy pink hats to her acid-pink robes. Her attire is ornamented in brooches and rings featuring portraits of cats. Her office desk includes cat-ornamented pink notepaper, a cat-topped letter opener, and a cat-adorned bottle of perfume. So it should be no surprise that hung on the pink stone walls of that office is a massive collection of plates featuring cats and kittens.

Set decorator Stephenie McMillan and her team worked with the art department and prop makers to make the decorative dishes. There was somewhere between one to two hundred images created for the kitten plates. "We first decided that the plates would be in tapering sizes," said Stephenie McMillan, "with the biggest ones at the top." The colorful fancy or flowered borders on the cat plates were all taken from real plates, then scanned and produced.

BEHIND THE MAGIC

In *Harry Potter and the Deathly Hallows – Part 1*, Dolores Umbridge is promoted to running the Muggle-Born Registration Commission for the Ministry of Magic, and continues the tradition of cat plates on the walls of her, again, very pink office. Though a majority of the kitten plates were used in her new digs, they did not mew or move, as only a short amount of time was spent there.

Forty kittens were brought into the studio, along with a large selection of props both magical and mirthful. Kittens were filmed dressed in ruffs around their necks, in knitted cardigans, and woolly jackets with a hat and scarf ensemble. Backgrounds for their exploits included a beach with sandcastles and seashells and a field of daisies that held a kitten in a wheelbarrow. And, of course, there were cats wearing a witch's hat and sitting in an empty cauldron. Other props included crystal balls, a goldfish bowl (with the goldfish mysteriously absent), and a mini motorcycle and sidecar.

The plates contained a combination of still pictures that were taken on the shoot or moving images that were added afterward. There were also a few plates where the cat had "wandered away." The filmed kittens were digitally placed on plates that had been covered in blue-screen material when filming the scenes in Umbridge's office.

71. HOG'S HEAD INN'S HOG'S HEAD

The Hog's Head Inn in Hogsmeade is not a particularly well-kept or populated place, so it's conducive to clandestine meetings, which is why Hermione chooses it to gather the interested students who eventually form Dumbledore's Army. When Hermione, Harry, and Ron first enter the Hog's Head, it's hard to avoid noticing a huge hog's head mounted on the wall, as it rolls his eyes, making snuffling noises, and dribbles onto the ground "profusely," as creature effects supervisor and special makeup effects artist Nick Dudman describes it. Dudman and his team were tasked with creating the Hog's Head's hog's head, and he knew it had to have broad movements. "It's a comic aside," he explains. "And those are always a pleasure to do, whether it's a one-off gag that will just help a scene along or give you a diversion for a minute."

The hog's head on the wall is seen fleetingly. However, "There's actually a lot of time that goes into creating something like this," Dudman explains. "It has to be sculpted and molded, then the skin is produced in silicone, and then it's painted." The most time-consuming aspect is that every single hair is inserted individually into the head. "But," he adds, "that gives it an air of realism you really can't achieve any other way."

"Lovely spot."

"I thought we'd be safer somewhere off the beaten track."

—RON WEASLEY AND HERMIONE GRANGER,
HARRY POTTER AND THE ORDER OF THE PHOENIX

BEHIND THE MAGIC

The Hog's Head has all the hallmarks of a typical London pub, with heavy oak beams, leaning walls, and an uneven floor. "But it leans more than any real pub ever could," says Stuart Craig. "The oak beams are heavier than you would ever find in a real pub. It's more decrepit and the wood is more worm-eaten than hopefully you would ever find in a real pub."

72. DUMBLEDORE'S ARMY SIGN-UP SHEET

In protest against Dolores Umbridge's refusal to teach defensive spells, Hermione Granger invites interested students to consider her idea that they must teach themselves. Harry begrudgingly agrees to lead this effort.

"We know that a war is coming," says Daniel Radcliffe, who felt that *Harry Potter and the Order of the Phoenix* had the feeling of a World War II–era film. "There's a real sense of a growing danger, but you can't define it. Things become scarier when you can't put a name to them," he continues. "We know it's Voldemort, but we don't know when it's going to happen, how it's going to happen, or what form it will take. There's the sense of mounting tension of a war being imminent."

Director David Yates wanted a feeling of wariness among the young wizards as they hear of Harry's exploits against Dark forces. "Not everyone's sure if he's telling the truth about whether Voldemort's back," says Alfred Enoch, who plays Dean Thomas. "So, there's a lot of tension in early scenes, even when they all sign up for Dumbledore's Army. 'Are we trusting this guy? Is he telling the truth?' It's interesting to see how, despite that, Harry takes them all onboard and teaches them and it becomes very enjoyable."

In order to cement their commitment to learning the defensive spells and being part of the newly christened Dumbledore's Army, members sign their names to a piece of paper. "It is at that moment," says producer David Heyman, "that Harry begins to realize his responsibility and his potential ability as a leader." The creation of this rebellious secret society is a sign that Harry has accepted his leadership role in the fight against Voldemort.

> Though the graphics department is usually tasked with creating handwriting for any papers or documents, the majority of signatures on the Dumbledore's Army parchment were inscribed by the actors themselves.

> **"This is mad! Who'd want to be taught by me? I'm a nutter, remember?"**
>
> **"Look on the bright side. Can't be any worse than old toadface."**
>
> —HARRY POTTER AND RON WEASLEY, *HARRY POTTER AND THE ORDER OF THE PHOENIX*

73. PROPHECY GLOBE

When Harry Potter sees a vision of Sirius Black in a crystal ball calling to him, he is convinced he must go to the Hall of Prophecy in the Ministry of Magic to rescue him. With four other members of Dumbledore's Army, Harry finds shelf after shelf of prophecy globes, but no Sirius Black—it was a ruse by Voldemort to bring Harry to the Ministry.

The Hall of Prophecy was the first set built entirely virtually for the films, with only a path marked out on the floor for the actors in a room entirely covered in green screen. Initially, a small portion of glass shelves bearing the globes was to be created. "I think we were supposed to make about thirteen thousand globes, altogether," recalled set decorator Stephenie McMillan, "which would be used for the background on glass shelves. The ones in front would be done by special effects." The globes would be from two inches to a foot and a half in size, tagged with names and numbers contributed by the graphics department. However, it was quickly realized that script requirements would prevent a practical version.

> "Prophecies can only be retrieved by those about whom they are made."
> —LUCIUS MALFOY, *HARRY POTTER AND THE ORDER OF THE PHOENIX*

Dumbledore's Army is confronted by Death Eaters, and spells are cast back and forth. Ginny Weasley casts *Reducto*, which brings down everything in the room in waves of shattered globes and glass. "We set out to build it for real," says production designer Stuart Craig, "and we experimented for a while with those glass spheres and their contents, and how we could make them truly mysterious, with some success. We were going to physically manufacture fifteen thousand glass spheres and place them on glass shelves. The whole thing was going to be a crystal palace covered in cobwebs and dust. Then we did a test and realized that when these shelves went crashing over, it was going to take weeks to replace and reset the orbs. David Yates decided that we should make it our first-ever completely computer-generated environment."

Neville Longbottom spots a globe labeled in black and red ink: S.P.T to A.P.W.B.D dark lord and (?) Harry Potter. The letters stand for "Sybill Patricia Trelawney to Albus Percival Wulfric Brian Dumbledore."

OPPOSITE: Concept work by Andrew Williamson of myriad prophecy globes for *Harry Potter and the Order of the Phoenix*
TOP: A snake-themed stand held the prophecy globe concerning Harry Potter
ABOVE: Numbered plates lined the Hall of Prophecy's shelves; Harry's prophecy was on row 97
LEFT: Digital artwork of Harry, Ron, Hermione, Neville, Ginny, and Luna fighting off Death Eaters in the Hall of Prophecy by Andrew Williamson

HARRY POTTER AND THE
HALF-BLOOD PRINCE

74. WEASLEYS' WIZARD WHEEZES MAGICIAN'S HAT STATUE

Weasleys' Wizard Wheezes on Diagon Alley sells gags, fireworks, defensive magic, and unique sweets. Although the wizarding market district has been partially destroyed by Death Eaters, the Weasleys' business is thriving.

"They weren't really cut out to be students," says James Phelps (Fred). "They were always practical jokers. Then they discovered they could use this to their advantage financially, as well as for entertainment. People can see them as just being a joke, but they're also quite streetwise. Now they're in their element."

Before the start of their sixth year at Hogwarts, Harry, Hermione, and Ron visit the shop, which is fronted by a twenty-foot-tall moving figure resembling one of the Weasley twins. Upon its head is a top hat that raises and lowers. In a twist on the traditional Muggle trick of a magician pulling a rabbit out of a hat, a rabbit appears and disappears every time the hat is raised. The rabbit's paws and ears wiggle back and forth while the statue's eyes look from side to side and its eyebrows go up and down. The ginger-haired figure is clearly a Weasley twin, but which Weasley? "It's Fred," claims James Phelps of his character. "It's of me because I'm the better-looking one." Oliver Phelps disagrees, claiming it's George. Why? "I have the funnier face."

> "How are Fred and George doing it? Half the Alley's closed down."
>
> "I reckon these people need a laugh these days."
>
> —HERMIONE GRANGER AND RON WEASLEY,
> *HARRY POTTER AND THE HALF-BLOOD PRINCE*

✷

TOP: Lift the hat once atop the statue in front of Weasleys' Wizard Wheezes and a rabbit appears. (Lift it again and the rabbit disappears)
LEFT: Fred and George Weasley (James and Oliver Phelps), successful entrepreneurs of their jokes and fireworks shop on Diagon Alley, first seen in *Harry Potter and the Half-Blood Prince*
OPPOSITE: Concept art of Weasleys' Wizard Wheezes exterior by Adam Brockbank

BEHIND THE MAGIC

The original tone of Diagon Alley's shops adhered to a uniform palette, "To create a harmony of light and shape," says production designer Stuart Craig. "In the case of the Weasleys' joke shop, we broke with that practice and deliberately made it as bright and less aged as anything else we'd done. It's brash, and extremely orange."

75. WEASLEYS' WIZARD WHEEZES PUKING PASTILLES DISPLAY

"Into the cauldron, handsome."

—FRED AND GEORGE WEASLEY,
HARRY POTTER AND THE HALF-BLOOD PRINCE

While students at Hogwarts, Fred and George Weasley developed the "Skiving Snackbox": confections that provide a way to get out of class. These sweets had two sides—one was charmed to cause a physical illness, the other provided the antidote. The original Snackbox contained Puking Pastilles, Nosebleed Nougat, Fever Fudge, and Fainting Fancies.

After the entrepreneurial twins open a joke shop on Diagon Alley, a six-foot-tall statue of a green-faced girl vomiting a never-ending cascade of Puking Pastilles was created to advertise one of Weasleys' Wizard Wheezes best sellers.

"We wanted it to be kind of funny and disgusting at the same time," says concept artist Adam Brockbank. "So, we came up with a giant, slightly badly sculpted kid throwing up into a bucket, so you can fill a cup under the stream of Puking Pastilles and then go and pay for it.

"Many items are described in the book," Brockbank continues, "but, really, what do they look like?" Miraphora Mina and Eduardo Lima had chosen a style for the marketing graphics on the toys and jokes sold in the shop that gave a nod to the cheap plastic and tin toys of the 1950s, so Brockbank took that idea, and referenced his own memories of the crudely designed charity donation boxes that sat outside shops in Britain in the 1950s, often of children and animals. "The Weasley style is obviously very inventive, but also slightly kitschy," says props art director Hattie Storey.

BEHIND THE MAGIC

The Puking Pastilles statue was constructed by the prop-making team headed by Pierre Bohanna, and, according to Hattie Storey, "was brought to life in sickening detail." Bohanna called the figure "brilliant nonsense." Then, more than a thousand silicon green-and-purple pastille candies were created to be "puked."

76. WEASLEYS' WIZARD WHEEZES LOVE POTIONS

> "Hello, ladies. Love potions, eh?"
>
> —FRED WEASLEY,
> *HARRY POTTER AND THE HALF-BLOOD PRINCE*

Another popular seller at Weasleys' Wizard Wheezes is their WonderWitch line of beauty products and love potions. Created with the idea of young witches in mind, the line runs from skin care, especially the Ten-Second Pimple Vanisher, and cosmetics such as Everlasting Eyelashes and Crush Blush.

Perhaps the most noticeable product in the line are the love potions, with the names First Love Beguiling Bubbles, Cupid Crystals, Flirting Fancies, and Kissing Concoction. There are also a few potions for broken hearts: Love Is Blind Eye Serum and Heartbreak Teardrops. These potions are sold in heart-shaped bottles showcased in several tiers of a violently pink-colored flower petal display that sends up tiny bubbles.

Horace Slughorn brewed Amortentia, the strongest love potion there is, in his first Potions class for sixth years.

OPPOSITE: Concept art by Adam Brockbank of the Puking Pastilles display that spews thousands of the sweets in Weasleys' Wizard Wheezes in *Harry Potter and the Half-Blood Prince*
TOP: Visual development art of a love potion bottle
LEFT: Display featuring WonderWitch love potions sold at Weasleys' Wizard Wheezes

77. LUNA LOVEGOOD'S SPECTRESPECS

On a special edition of *The Quibbler* passed out by Luna Lovegood on the Hogwarts Express are a pair of Spectrespecs, ready to be punched out of the issue for wear. Spectrespecs make it possible for one to see Wrackspurts, magical creatures so small they seem invisible.

Though most versions of *The Quibbler* were printed on a thin paper suggestive of a tabloid-style magazine, this edition's front page was printed on a heavier stock that allowed for perforations around the glasses so they could be removed.

Fortunately, Luna is wearing a pair of Spectrespecs as she walks down the corridors of the Hogwarts Express after it arrives in Hogsmeade, and is able to find a missing and injured Harry Potter in the Slytherin car.

Graphics designer Miraphora Mina was inspired by 1960s pop art for the "eye-catching" spectacles.

"Luna! How did you know where I was?"

"Wrackspurts. Your head's full of them."

—HARRY POTTER AND LUNA LOVEGOOD,
HARRY POTTER AND THE HALF-BLOOD PRINCE

78. BUTTERBEER LABEL

Butterbeer is ubiquitous in the wizarding world, served from the Leaky Cauldron in London to the Three Broomsticks and the Hog's Head in Hogsmeade. As the wizarding world expands, it's found in all corners of the world, with a sweet, butterscotch-like flavor and a foam with a tendency to cling to one's top lip.

The first Butterbeer label was created by graphic designers Miraphora Mina and Eduardo Lima, and through the course of the films, they created a rich history for this popular drink, which dates back to the late Middle Ages. "From the original 1550 Leaky Cauldron recipe," the label later states. The original label features a simple medieval-like font in hues of green, gold, and orange. A stylized double *B* was later established as a logo for the brand that is also reminiscent of a honeybee.

Butterbeer has gone beyond the shores of the British Isles as the wizarding world expands in space and time: Mina and Lima have created Butterbeer bottle labels for the brand for Harry Potter's time in the 1990s, and for 1920s Britain, 1920s Paris (Beirau Beurre), and 1930s Bhutan (the "best brand," and produced there), seen in the Fantastic Beasts films. The latter features a stylized ox or yak on the label rendered in a woodcut block style.

> "Does anyone fancy a Butterbeer?"
>
> —HARRY POTTER,
> *HARRY POTTER AND THE HALF-BLOOD PRINCE*

A small keg of Butterbeer is set up on a table in the Gryffindor common room in *Harry Potter and the Half-Blood Prince* to celebrate their Quidditch victory over Slytherin.

OPPOSITE TOP: Spectrespecs, which make Wrackspurts visible to the wearer
OPPOSITE MIDDLE: By wearing Spectrespecs, Luna Lovegood (Evanna Lynch) can find a hidden Harry Potter on the Hogwarts Express by the Wrackspurts flying around his ears
OPPOSITE BOTTOM: Evanna Lynch as Luna Lovegood in a publicity still for *Harry Potter and the Half-Blood Prince*
TOP: The first Butterbeer label created by the graphics department
RIGHT: A stack of Butterbeer casks at the bar on the set of the Three Broomsticks

79. ADVANCED POTION-MAKING

Harry and Ron are sent to Potions class in their sixth year, which they did not expect to take. Neither has that year's Potions book, so returning Potions Professor Slughorn advises them to get one from the classroom's cupboard. Seeing one battered, old version and one clean, new version of the book, the young wizards fight between them before Ron comes up the victor with the newer book.

For this prop, explains graphic designer Miraphora Mina, "we had only a few seconds on-screen to show to the audience why they both want *this* book and neither of them want *that* book. You've got to remember how it was as a child," she continues. "'I want the shiny one. I'm not going to have that crappy, dirty one.'" New and old versions had to be quickly identifiable as the same book, but different editions. The second edition of *Advanced Potion-Making* has a broken spine, with a Victorian feel in its lettering and faded graphic of a smoking cauldron. The more recent fourth edition is smaller, has simple, clean lines, and though it still sports cauldrons, they're stylized to its 1970s publication date.

Harry discovers notes and corrections made in his book, inscribed by the Half-Blood Prince, revealed to be Severus Snape. Miraphora Mina was tasked with creating Snape's handwriting. "I had to imagine how Snape would write. Probably he wouldn't have it all tidy and in the same direction, with lots of thinking and scrubbing out." Though the notes are haphazardly placed on the pages, with blots and smears of ink, the information speaks to the brilliance of the writer.

> "This book is the property of the Half-Blood Prince."
>
> —SEVERUS SNAPE, *HARRY POTTER AND THE HALF-BLOOD PRINCE*

BEHIND THE MAGIC

Scribbled in one margin is the curse *Sectumsempra*, which Harry casts upon Draco Malfoy during a wand battle without knowing its consequences. Severus Snape showing up to chant the countercurse is a clue to the Half-Blood Prince's identity.

THIS PAGE: Various iterations of the *Advanced Potion-Making* textbook used by sixth-years at Hogwarts
INSET: Severus Snape's scrawled notes in his copy of *Advanced Potion-Making* help Harry to excel in the subject in *Harry Potter and the Half-Blood Prince*
OPPOSITE TOP: Close-up of the Felix Felicis bottle to be won in Horace Slughorn's sixth-years Potions class
OPPOSITE BOTTOM: Harry (Daniel Radcliffe) shows Hermione (Emma Watson) that he has not yet opened the bottle of Felix Felicis when she assumes he gave some to Ron before his Quidditch game

80. FELIX FELICIS POTION BOTTLE

The first test Potions Professor Horace Slughorn gives to his sixth-year students is to create the "Draught of Living Death," one of the most powerful sleeping potions, and one of the most difficult potions to produce. As a reward to the student who can brew an acceptable draught, Slughorn is offering one tiny vial of Felix Felicis, also known as Liquid Luck.

Harry's tattered, early edition of *Advanced Potion-Making* previously used by the Half-Blood Prince ends up being his secret to success. Harry follows the Prince's instructions and wins the Felix Felicis.

The Felix Felicis vial was created by supervising modeler Pierre Bohanna, who created the smallest bespoke potion vials. An appropriately size cauldron and clamp were also created for the tiny bottle.

> "Desperately tricky to make. Disastrous if you get it wrong. One sip and you will find that all of your endeavors will succeed. At least until the effects wear off."
> —HORACE SLUGHORN, *HARRY POTTER AND THE HALF-BLOOD PRINCE*

Daniel Radcliffe would love to try Felix Felicis. "If you have too much, apparently it screws you up," he says, "but the idea of having that perfect day is just so wonderful."

81. POTION BOTTLE LABELS

Designer Miraphora Mina estimates that throughout the course of the films, the graphics department made thousands of labels, with the highest percentage being those for potions. There are bottles of Essence of Dittany and Pepperup Elixir. Boxes of bezoars and Belch Powder. There's also Armadillo Bile Mixture No. 440, Sliced Caterpillar, and the extremely poisonous Potion No. 07.

For Severus Snape's Potions class in *Harry Potter and the Sorcerer's Stone*, five hundred bottles, jars, and vials of varying sizes were placed on shelves and desks. They ranged in size from two inches to more than two feet. Every potion bottle was given a label handwritten by the graphics department that contained the ingredients, serial numbers, and warnings, aged with splatters and spots. Singular ingredient jars contained ginger roots, dried herbs, rubber lizard tails, baked animal bones from a local butcher shop, and plastic animal toys from the gift shop of ZSL London Zoo in Regent's Park. The number of bottles increased for Snape's office in *Harry Potter and the Chamber of Secrets*, and in *Harry Potter and the Goblet of Fire*, there's a quick peek into Snape's fully stocked storeroom. Potions Professor Horace Slughorn's classroom was double the size of Snape's, and doubled the amount of potion bottles to one thousand.

Labels were also created for Mr. Mulpepper's and Slug & Jiggers Apothecary on Diagon Alley, and for classes and storerooms at Hogwarts, each requiring their own specific branding. Polyjuice Potion bottles and individual ingredients, including Lacewing flies and Boomslang skin stored in Professor Snape's storeroom in *Harry Potter and the Goblet of Fire*, were labeled from the Hogwarts Potion Dept.

> " . . . for those select few who possess the predisposition, I can teach you how to bewitch the mind and ensnare the senses. I can tell you how to bottle fame, brew glory, and even put a stopper in death."
>
> —PROFESSOR SNAPE,
> *HARRY POTTER AND THE SORCERER'S STONE*

TOP, RIGHT, AND OPPOSITE BOTTOM LEFT: Potion bottle labels, including serial numbers, ingredients, and warnings, were handwritten by the graphics department
OPPOSITE TOP: More than one thousand potion bottles were filled and labeled by the graphic and prop departments between Severus Snape's and Horace Slughorn's tenure in the position
OPPOSITE BOTTOM RIGHT: Publicity still of Alan Rickman as Severus Snape, Potions master for Harry's first five years at Hogwarts

BEHIND THE MAGIC

When Potions Master Horace Slughorn returns to Hogwarts in *Harry Potter and the Half-Blood Prince*, he arrives with a trunk filled with bottles from his own "Apothecarium." In the same film, the Hogwarts Potion Dept. was renamed the Hogwarts Apothecary, which stockpiled skinned Shrivelfig.

82. MARVOLO GAUNT'S RING

> "They could be anything. The most commonplace of objects. A ring, for example..."
> —ALBUS DUMBLEDORE,
> *HARRY POTTER AND THE HALF-BLOOD PRINCE*

Tom Riddle can be seen wearing Marvolo Gaunt's ring in Horace Slughorn's memories in *Harry Potter and the Half-Blood Prince*.

After Harry and Dumbledore view the real memory of Potions Professor Horace Slughorn being manipulated into explaining Horcruxes to his student Tom Riddle, Dumbledore realizes that not only has Voldemort successfully made one Horcrux, he made even more. Dumbledore shows Harry a gold ring with a black stone from Voldemort's mother that is another Horcrux.

Designed by graphics artist Miraphora Mina, the ring has an almost black-colored gem held in the mouth of two stylized snakes, reflecting its Slytherin origins. Dumbledore is able to destroy this Horcrux, but at a great cost. In doing so, the ring has cursed him with burnt and withered fingers. Actor Michael Gambon (Dumbledore) wore green-screen material over his hand for the special effects team to create the injury digitally.

Marvolo Gaunt's ring is the only Horcrux that is also a Deathly Hallow; the gem in the ring is the Resurrection Stone, and bears the symbol of the Deathly Hallows. "We were as much in the dark as everyone else when we first started designing the Stone for the ring Dumbledore had in the sixth film," recalls props art director Hattie Storey. "Luckily, the seventh book came out before we had to finish designing that prop," she continues, "because we hadn't known that it needed the symbol for the Deathly Hallows etched on it—and that symbol was still in development." Storey remembers reading the seventh book in a great hurry, "and what we learned changed our ideas for the Stone."

83. WANTED POSTERS OF DEATH EATERS

As the Ministry succumbs to the rise of Voldemort's power in *Harry Potter and the Half-Blood Prince*, they make a last feint at rounding up the Death Eaters who had broken out of Azkaban Prison and those who were still in the general populace. Wanted posters are plastered on the walls of Diagon Alley and Knockturn Alley in London.

Graphics designer Miraphora Mina considers these posters to be much more sophisticated than the one created for Sirius Black. These Wanted posters display three images (right profile, front, and left profile) and list their crimes. There is a considerable amount of text added, including an actual monetary amount for the reward for information (1,000 Galleons). These broadsides have been stamped with the Ministry of Magic logo and the signature of the Minister for Magic. Death Eater Lucius Malfoy has been caught, so his poster is a more general one that asks for information about other possible Death Eaters and to remain vigilant.

The actors were filmed in live action for scenes to be placed onto the posters in postproduction. A green-screen box was inserted where the images of the wanted Death Eaters would be placed.

> ### "DEATH EATERS ARE AMONG US!"
> —LUCIUS MALFOY "CAUGHT" POSTER, *HARRY POTTER AND THE HALF-BLOOD PRINCE*

BEHIND THE MAGIC

The Wanted posters were "damaged" by the graphic artists to show the wear and tear of vandalism as they hung on the walls. They are torn, stained, and show evidence of water damage from rough weather and smoke damage from the attack on Diagon Alley.

OPPOSITE TOP: Visual development art by Adam Brockbank of the Resurrection Stone Horcrux in Marvolo Gaunt's ring
OPPOSITE MIDDLE: Marvolo Gaunt's ring was in Albus Dumbledore's possession during the events of *Harry Potter and the Half-Blood Prince*
OPPOSITE BOTTOM: Close-up of the Resurrection Stone set in Marvolo Gaunt's ring
THIS PAGE: Wanted posters of Death Eaters, made to appear weathered and worn by the graphics department

> The label of the box containing the Bezoar that saves Ron says it was prepared by the E.M.L. Potions Co., the first initials of graphic designers Miraphora Mina, Eduardo Lima, and Lauren Wakefield.

ABOVE: Harry (Daniel Radcliffe) searches Horace Slughorn's potions trunk for a cure when Ron is accidentally poisoned in *Harry Potter and the Half-Blood Prince*
RIGHT: Graphic artist Eduardo Lima described Slughorn's potions bottles as "having been around for years and years"
OPPOSITE TOP: The purple velvet lining and gold embellishments on Slughorn's trunk speak to the professor's flair and fashion
OPPOSITE BOTTOM: Horace Slughorn (Jim Broadbent) in his earlier years at Hogwarts, seen in a Pensieve memory in *Harry Potter and the Half-Blood Prince*

84. HORACE SLUGHORN'S POTIONS TRUNK

Albus Dumbledore persuades former Potions Master Horace Slughorn to return to Hogwarts, in hopes of acquiring a memory Slughorn has of Voldemort that holds a vital clue to the Dark wizard's knowledge of Horcruxes.

Once Slughorn takes the post, he brings his trunk, filled with potions designated to be from his own private "Apothecarium." The trunk's shelves and drawers are covered with a lush, velvety fabric, embellished with gold locks and drawer pulls, but the fabric is washed-out, and the gold is tarnished.

"Professor Slughorn was a fun character, because he had quite a lot of accoutrements that he brought with him," says props art director Hattie Storey. "[Set decorator] Stephenie McMillan found this old traveling trunk, one of those ones that has a wardrobe on one side and cupboards on the other, that was lined with purple silk, and we added bits to it and filled it with potions."

Each potion ingredient box or bottle was individually hand-labeled by the graphics department. "I think we designed thirty different labels," says Eduardo Lima. "It's from his apothecary, so all the labels are written in his name." The designers developed a specific handwriting and label style for the professor's stores.

When Ron becomes enchanted by a love potion, Harry brings him to the professor, who prepares a successful counteragent. But then Slughorn offers them a pick-me-up of mead, and Ron drops to the floor, poisoned. Harry rifles through the trunk looking for an antidote and spots a box of Bezoars, which can cure most poisons.

> "I would have thought you could whip up a remedy for this in no time, Harry."
>
> "Oh, I thought this called for a more practiced hand, Sir."
>
> —HORACE SLUGHORN AND HARRY POTTER,
> *HARRY POTTER AND THE HALF-BLOOD PRINCE*

85. HORACE SLUGHORN'S HOURGLASS

Potions Master Horace Slughorn has a unique hourglass in his office that keeps time in an unusual way. The sands inside flow quickly or slowly, depending upon the quality of the conversation around it. For a good conversation, the sands run slow, allowing more time for wit and insight. If the exchange is not agreeable, the sands run quickly.

The hourglass is seen in Slughorn's office during two Pensieve memories showing Tom Riddle questioning the potions professor about Horcruxes. Harry Potter notices he still has it in his office. "Slughorn is a social climber," explains executive producer David Barron. "He loves knowing the best people and being able to name-drop the celebrities of their world." As Dumbledore rightly surmises, Harry is what actor Jim Broadbent (Slughorn) calls "the big bait for him. Harry Potter is a star he can add to his mantlepiece."

Slughorn's hourglass was an invention for the films, designed by Miraphora Mina. Six green-and-silver snakes form the handles, with three meeting at the top and three meeting to become the base. In another nod to Slughorn's Slytherin house, green sand runs in the green-tinted glass.

> "A most intriguing object. The sands run in accordance with the quality of the conversation. When it is stimulating, the sands run slowly . . . If it is not . . ."
>
> —HORACE SLUGHORN,
> *HARRY POTTER AND THE HALF-BLOOD PRINCE*

BEHIND THE MAGIC

"The level of detail of items such as this one is fantastic," says production designer Stuart Craig. "The hourglass in Slughorn's office is an exquisitely made prop, with spectacular detail. There's a richness you get from that kind of detail."

OPPOSITE TOP: Concept art of Horace Slughorn's Hourglass by Miraphora Mina
OPPOSITE BOTTOM: Harry (Daniel Radcliffe) admires the hourglass when he visits the office of Professor Slughorn (Jim Broadbent)
ABOVE LEFT: Jim Broadbent as Potions professor Horace Slughorn in a publicity still for *Harry Potter and the Half-Blood Prince*
ABOVE: The realized hourglass, fashioned with a nod toward Slughorn's Slytherin house

86. CURSED OPAL NECKLACE

When Draco Malfoy joins the Death Eaters to follow Voldemort, he is tasked with killing Albus Dumbledore. His first attempt is with a cursed opal necklace he purchased at Borgin and Burkes in Knockturn Alley. The opal necklace is picked by Gryffindor Katie Bell at the Three Broomsticks, who screams after touching it, then rises in the air before quickly dropping to the ground.

The opal necklace was designed by Miraphora Mina, whose mother was a jewelry maker. Mina was inspired by Victorian German iron "blackwork" jewelry. The necklace is made of an ornate filigree silver that has been oxidized to give it its distinctive black hue, and is set with iridescent green opals.

> "Oh, Severus. What do you think?"
>
> "I think Miss Bell is lucky to be alive."
>
> —MINERVA MCGONAGALL AND SEVERUS SNAPE, *HARRY POTTER AND THE HALF-BLOOD PRINCE*

TOP: The cursed opal necklace, designed by Miraphora Mina for *Harry Potter and the Half-Blood Prince*
ABOVE: Severus Snape (Alan Rickman) inspects the cursed necklace as Hermione Granger (Emma Watson), Minerva McGonagall (Maggie Smith), and Harry Potter (Daniel Radcliffe) wait for his opinion
OPPOSITE TOP: Concept art of the Crystal Cave scoop by graphic artist Miraphora Mina
OPPOSITE BOTTOM: Visual development art by Adam Brockbank of Harry helping Dumbledore drink the basin's potion as they strive to retrieve the Slytherin Horcrux locket

BEHIND THE MAGIC

The opal necklace was first seen by Harry at Borgin and Burkes, after he falls into it via a Floo powder mistake in *Harry Potter and the Chamber of Secrets*. It bears the sign: *"Do not touch! Cursed. Has claimed the lives of nineteen Muggle owners to date."*

87. CRYSTAL CAVE SCOOP

As they search for Horcruxes together, Dumbledore and Harry find themselves in a seaside cave. At the center of a lake in the cave is a small island, where Voldemort has placed a liquid-filled basin, which Dumbledore believes holds a Horcrux. Dumbledore must drink the liquid before acquiring the Horcrux.

A small scoop is fastened to the basin. "We had originally envisioned a metal cup attached by a chain for Dumbledore to drink from," says props art director Hattie Storey. "But then we felt it had to be something that looked as though it could be found in the cave, where there wasn't anything but crystal, and appear semi manmade. It was obviously found or created on the spot by Voldemort for the purpose of drinking the potion." Miraphora Mina's inspiration for the artifact was an ancient jade scoop with a sheep's head carved on it that fit the idea for the organic, crystalline shell-shaped prop. The scoop was created through a series of molds to give it the nature of a growing crystals. "Six molds in a series of progressive shapes each molded a particular part," says supervising modeler Pierre Bohanna. The first piece molded and cast would be placed in a second mold that cast the next piece upon it, and so on. Different processes for molding were used to create different effects. Parts of the scoop are pearlescent; others have fractures in them to appear as if the uncarved scoop had first grown naturally.

> "It is your job, Harry, to make sure I keep drinking this potion even if you have to force it down my throat. Understood?"
>
> —ALBUS DUMBLEDORE,
> *HARRY POTTER AND THE HALF-BLOOD PRINCE*

The Crystal Cave scoop was duplicated eight times, although none match exactly.

88. VANISHING CABINET

When Harry, Ron, and Hermione visit Diagon Alley before their sixth year at Hogwarts, they spot Draco and Narcissa Malfoy heading to Borgin and Burkes in Knockturn Alley. There, the trio watches as they gather in front of a large, triangular-shaped cabinet. Harry brings his concerns to Arthur Weasley, who explains what they saw is a Vanishing Cabinet. Unknown to Harry at the time, Draco is repairing a twin Vanishing Cabinet in the Room of Requirement at Hogwarts.

The Room of Requirement seen in *Harry Potter and the Half-Blood Prince* is filled with a hodgepodge of artifacts, so production designer Stuart Craig wanted a tall, simple silhouette for the Vanishing Cabinet to distinguish it among the clutter. "Director David Yates wanted the cabinet to look mysterious and threatening," says props art director Hattie Storey. "Stuart saw this as the best way to convey that feeling in a set overflowing with an eclectic array of other props and furniture." The dark, obelisk-shaped cabinet, covered in ancient flaking lacquer, has an intricate brass locking mechanism created by Mark Bullimore, who also designed the locks for Gringotts and the Chamber of Secrets.

LEFT: The Vanishing Cabinet, one of two used by the Death Eaters to gain access to Hogwarts in concept art by Andrew Williamson
BOTTOM LEFT AND RIGHT: The Vanishing Cabinet on the set of *Harry Potter and the Half-Blood Prince*, showing the empty interior
OPPOSITE TOP: Draco Malfoy (Tom Felton) incants *Harmonia Nectere Passus* as he attempts to repair the Vanishing Cabinet
OPPOSITE BOTTOM: Digital visual development art by Andrew Williamson features Draco Malfoy eclipsed by the voluminous Room of Requirement

"Harmonia Nectere Passus."
—DRACO MALFOY, *HARRY POTTER AND THE HALF-BLOOD PRINCE*

Borgin and Burkes also has a Crushing Cabinet among its artifacts, used by Harry Potter to hide from the Malfoys in *Harry Potter and the Chamber of Secrets*.

HARRY POTTER AND THE
DEATHLY
HALLOWS – PART 1

HEREIN IS SET FORTH THE LAST WILL AND TESTAMENT OF
Albus Percival Wulfric Brian Dumbledore

Maecenas dictum nisl sed sapien malesuada consequat. Donec suscipit, leo id tristique consequat, tortor ante suscipit odio, quis malesuada eros ligula a nisl. Donec sed erat vitae tortor hendrerit condimentum. Aliquam erat volutpat. Mauris imperdiet lorem ut lorem vehicula in cursus odio eleifend.

In nulla urna, pulvinar vel luctus vitae, interdum sed ligula. Curabitur scelerisque est sed erat varius convallis. Suspendisse imperdiet venenatis tincidunt. Nunc hendrerit elit at magna rutrum eget egestas tortor viverra.

Probatum

Sed a neque ut odio faucibus pretium nec ac lacus. Fusce vel neque non quam vehicula feugiat et quis nunc. Vestibulum fermentum, purus quis ornare hendrerit, turpis sapien interdum ipsum, eget imperdiet erat non ante nibh. Aliquam quam augue, lacinia at aliquam vitae, elementum porttitor urna. Sed purus metus, condimentum sit amet adipiscing ultricies, molestie vitae urna. Vestibulum placerat venenatis nisl, dictum imperdiet enim feugiat a. Nunc eu suscipit ligula. Donec nulla ipsum, condimentum ut volutpat ut, egestas sit amet urna. Etiam non tellus nunc, non sollicitudin diam.

First To... Ronald Bilius Weasley — I leave my *Deluminator*, a device of my own making, in the hope that, when things seem most dark, it will show him the light.

To Miss... Hermione Jean Granger — I leave my copy of *The Tales of Beedle the Bard*, in the hope that she will find it entertaining and instructive.

To... Harry James Potter — I leave the *Snitch* he caught in his first match at Hogwarts, as a reminder of the rewards of Perseverence and Skill. I bequeath, also, the *Sword of Godric Gryffindor*, being that it so wisely sought Harry Potter in true times of need.

89. ALBUS DUMBLEDORE'S WILL

In *Harry Potter and the Deathly Hallows – Part 1*, Minister for Magic Rufus Scrimgeour arrives at The Burrow to read bequests made by Albus Dumbledore to Harry, Ron, and Hermione in his will. Actor Bill Nighy (Scrimgeour) wondered doing something as innocent as leaving Hermione the copy of *The Tales of Beedle the Bard* could be "a perfectly sweet, sentimental gift in memory of her early life when she enjoyed those stories. But you never know," he says. "It could actually be an elaborate code, a secret language that they had. So, he is left bemused."

> **"'Herein is set forth the Last Will and Testament of Albus Percival Wulfric Brian Dumbledore.'"**
>
> —RUFUS SCRIMGEOUR, *HARRY POTTER AND THE DEATHLY HALLOWS – PART 1*

Miraphora Mina and Eduardo Lima designed Dumbledore's will with layers, similar to the idea of the Marauder's Map, though these were made to appear as codicils added on later. "That maybe at the last minute he's added in the stuff for the three kids," says Mina. Wanting to ensure that the will looked like an important legal document, it was "written" in Latin and ornamented with seals and symbols. Documents such as this would be handwritten by professional calligraphers; this one was rendered in a style of calligraphy known as "copperplate," which dates back to the 1660s.

According to *Part 1* director David Yates, the items Dumbledore gives to Harry, Ron, and Hermione seem odd to their upcoming task of locating the Horcruxes. "The mission is to go out and hunt and destroy Horcruxes," he explains. "So you're expecting something really cool to do this. You're expecting to get some serious Horcrux-killing stuff, and you end up with these slightly childish objects. But Dumbledore being Dumbledore," he notes, "these all have some meaning later on in our story and our journey."

The raised initial P in the word Probatum ("tested") is made up partially of a dragon. Artwork such as this within a document would signify the elevated status of the deceased.

90. XENOPHILIUS LOVEGOOD'S DEATHLY HALLOWS NECKLACE

While at the wedding of Bill Weasley and Fleur Delacour, Harry meets Luna Lovegood's father, Xenophilius, who is wearing a pendant featuring an unfamiliar symbol. When Hermione sees this same symbol in the copy of *The Tales of Beedle the Bard* gifted to her by Dumbledore, it's decided that perhaps the Lovegoods can be of some help to them.

BEHIND THE MAGIC

Rhys Ifans says of his character, Xenophilius Lovegood, "He's kind of jumpy and busy and eccentric, you know. But not mad."

100 OBJECTS

162

"Firstly, they go to visit Luna," says Rhys Ifans, who plays Xenophilius, "who is their friend. But they're also there to ask Xenophilius about the meaning of the Deathly Hallows, which he knows about." Lovegood draws and explains the symbol to them. Unbeknownst to the trio, Luna has been taken by Voldemort as punishment for the pro-Harry, anti-Voldemort sentiment Lovegood publishes in his magazine. If Xenophilius has any chance of getting her back, he must turn in Harry Potter. "He's put in a terrible position," says Ifans, "where he's championed Harry Potter's cause all Harry's life, and he's faced with this gargantuan dilemma. Now he's faced with the loss of his daughter, and he cracks."

Until they are revealed, the Deathly Hallows have been in plain sight throughout the course of the films; Harry already has the Invisibility Cloak, given to him in *Harry Potter and the Sorcerer's Stone*. Dumbledore is the master of the Elder Wand until it is taken by Voldemort after his death in *Harry Potter and the Half-Blood Prince*. The Resurrection Stone was housed in a Horcrux made from Marvolo Gaunt's ring seen in *Half-Blood Prince* until Dumbledore destroys the ring. The Stone itself is later left to Harry by Dumbledore inside the Golden Snitch.

> **"What is it? Well, it's the sign of the Deathly Hallows, of course."**
>
> **"The what?"**
>
> —XENOPHILIUS LOVEGOOD, HARRY POTTER, HERMIONE GRANGER, AND RON WEASLEY, *HARRY POTTER AND THE DEATHLY HALLOWS – PART 1*

OPPOSITE PAGE: Xenophilius Lovegood (Rhys Ifans) wears a necklace bearing the symbol of the Deathly Hallows, which he explains to Harry, Ron, and Hermione as they search for information about Voldemort in *Harry Potter and the Deathly Hallows – Part 1*
THIS PAGE: Hermione (Emma Watson), Ron (Rupert Grint), and Harry (Daniel Radcliffe) watch as Xenophilius Lovegood (Rhys Ifans) draws and explains each element in the symbol for the Deathly Hallows: the Elder Wand, the Resurrection Stone, and the Cloak of Invisibility

When the trio escape to the Muggle world, Ron uses the Deluminator to put out the lights in the Luchino Caffe trying to elude Death Eaters in *Harry Potter and the Deathly Hallows – Part 1*.

91. DELUMINATOR

As Hogwarts Headmaster Albus Dumbledore walks to the Dursleys' house on Privet Drive, he takes a mechanical device and clicks the top, whereupon the lights in the lamps lining the sidewalk fly into the mechanism. Once done, he puts the object—the Deluminator—away.

The Deluminator is seen again in *Harry Potter and the Deathly Hallows – Part 1*, as an item gifted to Ron Weasley per Dumbledore's will. The current Minister for Magic, Rufus Scrimgeour, expects Ron to identify and recognize the object. "He doesn't," actor Bill Nighy explains. "He doesn't know what it is." Ron quickly discovers the light-sucking aspect of the device, but he is at a loss as to why the headmaster would bestow this particular item on him.

After Harry, Hermione, and Ron go on the run searching for Horcruxes, Ron becomes jealous of Harry and Hermione, and fearful for his family, so he Apparates away. When he returns, Ron explains how he was able to find them: Hermione's voice came from the Deluminator, whispering his name. "When he comes back, he's enlightened," Rupert Grint explains. "He's done a lot of thinking and he comes back a different person. He realizes how important Hermione is to him, how much he does actually care about her."

Although the artifact could not capture light, it was still a practical device, built in two versions. Dumbledore's Deluminator had caps on its malachite cylinder. When a switch on the side is moved, one cap would flip up, and then a smaller cap would rise up that was the piece that magically took in or released light. Ron's version was created in a smaller form. "We remade it," says supervising modeler Pierre Bohanna, "because we thought Dumbledore might have updated it."

> **"'First, to Ronald Bilius Weasley, I leave my Deluminator, a device of my own making, in the hope that— when things seem most dark— it will show him the light.'"**
>
> —RUFUS SCRIMGEOUR READING FROM THE LAST WILL AND TESTAMENT OF ALBUS DUMBLEDORE, *HARRY POTTER AND THE DEATHLY HALLOWS – PART 1*

OPPOSITE TOP: Hermione (Emma Watson), Ron (Rupert Grint), and Harry (Daniel Radcliffe) are initially confused by the items Dumbledore has left them, especially Ron, who is bequeathed the Deluminator
OPPOSITE BOTTOM: Ron uses the Deluminator while imprisoned in Malfoy Manor with Griphook (Warwick Davis), Ollivander (John Hurt), and Luna Lovegood (Evanna Lynch) in *Harry Potter and the Deathly Hallows – Part 1*
TOP: The final Deluminator prop, also known as the "Put-Outer," as seen in *Harry Potter and the Deathly Hallows – Part 1*
BOTTOM: Early visual development art of the Deluminator by Peter McKinstry

92. SALAZAR SLYTHERIN'S LOCKET

Voldemort created seven Horcruxes, three of which were made from items related to the founders of Hogwarts. One of the most difficult to acquire and destroy was the Salazar Slytherin locket Horcrux.

At the time the graphic designers and prop makers began work on the locket, they were unaware that the one in the Crystal Cave was a decoy created by Sirius Black's younger brother, Regulus Arcturus. Both the real and fake versions feature a green jeweled S on the front. "The locket is twisty and complex," says production designer Stuart Craig, "not unlike Slytherin himself."

The real Slytherin locket is more refined, with the S on the front laid out cleanly in square-cut dark green gems point to point. Around the face are astrological symbols and aspect notations used for horoscopes, and on the back is Slytherin's name surrounded by runes. "The locket was a challenge," says Miraphora Mina, "because it was full of evil, but it also needed to have a beauty to it; to be something appealing and something historical."

Mina based her design on an eighteenth-century piece of jewelry from Spain, and gave hers "a sort of chamber inside." On the real locket, this "chamber" houses an eye; for the fake version, it holds the tiny note Regulus has left. To Mina, the locket was a treat to conjure up. "I was allowed to play with every detail on that locket," she explains, "so even the loop that goes onto the chain is a little snake wound around it. The great thing on Harry Potter was that all these things were manufactured on-site, so discussions could take place with the prop maker about the right materials to use, and that would perhaps necessitate an alteration of the design a little bit."

TOP: The fake Slytherin Horcrux locket created by Regulus Arcturus, seen in *Harry Potter and the Half-Blood Prince*
LEFT: After Ron (Rupert Grint) rescues Harry (Daniel Radcliffe) from under an icy lake to retrieve the Sword of Gryffindor, Ron uses the sword to destroy the Horcrux locket
OPPOSITE LEFT: The real Slytherin Horcrux locket created by Lord Voldemort, as seen in *Harry Potter and the Deathly Hallows – Part 1*
OPPOSITE RIGHT TOP: Inside of the real Slytherin locket. When opened, a digitally placed eye regarded its attackers
OPPOSITE RIGHT BOTTOM: The destroyed Slytherin Horcrux locket, one of forty copies needed for filming

BEHIND THE MAGIC

It isn't until Harry and Ron obtain the Sword of Gryffindor that the locket can be destroyed. After Harry opens it by speaking Parseltongue, Ron uses the Sword to cut it in two. For this sequence, forty duplicates of the locket were needed.

"'To the Dark Lord, I know I will be dead long before you read this, but I want you to know it was I who discovered your secret . . . I have stolen the real Horcrux and intend to destroy it as soon as I can. I face death in the hope that when you meet your match, you will be mortal once more. R.A.B.'"

—HERMIONE GRANGER READING THE NOTE IN THE FAKE SLYTHERIN LOCKET, *HARRY POTTER AND THE HALF-BLOOD PRINCE*

> "Mum used to read me those. 'The Wizard and the Hopping Pot.' 'Babbitty Rabbitty and the Cackling Stump.' Come on. Babbitty Rabbitty. No?"
>
> —RON WEASLEY, *HARRY POTTER AND THE DEATHLY HALLOWS – PART 1*

TOP: The three brothers cast a bridge to cross a river in the animated *The Tale of the Three Brothers* sequence, as narrated by Hermione in *Harry Potter and the Deathly Hallows – Part 1* from *The Tales of Beedle the Bard*. Color key reference art by sequence supervisor Dale Newton for the lighting and animations teams.
RIGHT: Interior pages for *The Tales of Beedle the Bard*, created by the graphics department
OPPOSITE TOP: Cover design for *The Tales of Beedle the Bard* by graphic artists Miraphora Mina and Eduardo Lima
OPPOSITE BOTTOM: Color key art by animation director Ben Hibon, illustrating Death departing with the second brother

93. THE TALES OF BEEDLE THE BARD

Dumbledore bequeaths Hermione Granger his copy of *The Tales of Beedle the Bard*, a popular children's book of imaginative tales and wizarding legends, similar to Muggles' fairy tales.

Graphic designers Miraphora Mina and Eduardo Lima wanted Dumbledore's copy of *The Tales of Beedle the Bard* to feel like a beloved tome, and so the spine is broken from myriad readings and gold leaf on the damaged cover is fading and falling off. They studied the art of bookbinding and learned the techniques of the craft as well as the ramifications of time on a book—where damage starts and what can endure in spite of age.

As with most books seen in the Harry Potter films, a series of pages would be created and repeated between the covers in case an actor opened the book. For *The Tales of Beedle the Bard*, Mina and Lima created chapter openers for each of the tales using laser-cut illustrations that would appear as black-and-white silhouettes of the characters, artifacts, or settings of each tale. Unfortunately, these were not seen on-screen.

> "'To Miss Hermione Jean Granger, I leave my copy of *The Tales of Beedle the Bard*, in the hope that she find it entertaining and instructive.'"
> —RUFUS SCRIMGEOUR READING FROM THE LAST WILL AND TESTAMENT OF ALBUS DUMBLEDORE, *HARRY POTTER AND THE DEATHLY HALLOWS – PART 1*

HARRY POTTER AND THE
DEATHLY HALLOWS – PART 2

94. MINISTRY'S MAGIC IS MIGHT STATUE

"Are those...?"

"Muggles...in their rightful place."

—HARRY POTTER AND HERMIONE GRANGER, *HARRY POTTER AND THE DEATHLY HALLOWS – PART 1*

The Magic is Might statue was cut in foam, and then hand-painted to appear like stone.

Up until the events of *Harry Potter and the Half-Blood Prince*, the Atrium of the Ministry of Magic featured two sculpted architectural pieces that in combination formed the "Fountain of Magical Brethren," representing harmony in the wizarding world. "Once you entered through the gilded fireplaces," says Stuart Craig, "you came upon that big, idealized statue, the gold statue of this perfect wizarding family: the witch, the wizard, the goblin, the centaur, and the house-elf." However, "it's a rather idealized collection of figures," he continues, "that belies the truth of what is going on in the Ministry at the time."

In *Harry Potter and the Deathly Hallows – Part 1*, Harry, Ron, and Hermione take Polyjuice Potion to transform into Ministry workers as they search for the Slytherin Horcrux Locket. Once inside the Atrium, they see the fountain has been replaced by a single monolithic sculpture that portrays the right of witches and wizard to oppress Muggles, titled "Magic is Might."

"It's still that same principle," says Craig of the design of the Atrium, "that big centerpiece we had, but that has changed. That is gone. That kind of idealized, romantic sculpture has been replaced by a massive piece."

Sculptor Julian Murray created the horrific statue, inspired by 1930s Soviet-era architectural propaganda. "Julian sculpted the statue, figure by figure, piece by piece," says special makeup effects artist Nick Dudman. Murray sculpted sixty interlocked figures, based on life studies of models, that bear the weight of the Ministry's tyranny on their backs—literally—in the form of a huge block topped by a triumphant witch and wizard.

95. PAINTING OF ALBUS DUMBLEDORE

At the end of the events in *Harry Potter and the Half-Blood Prince*, Dumbledore is confronted by Draco Malfoy, who has been tasked with killing the headmaster, but he cannot get himself to follow through with Voldemort's command. Severus Snape suddenly appears and casts *Avada Kedavra*. Harry returns to Dumbledore's office and spots a newly hung portrait of a sleeping Dumbledore, a tribute given to all the Hogwarts headmasters who have passed away.

Harry has thrived under Dumbledore's guidance and encouragement since his infancy, when the Hogwarts headmaster left the infant at his aunt and uncle's for protection from Voldemort. Daniel Radcliffe believes that, for many years, Harry's relationship with Dumbledore was very much like father and son. "Dumbledore didn't have children, Harry wanted a father figure, and it worked quite nicely," he says. "But over the course of the films, it becomes more about finding and destroying Voldemort, so Harry becomes a foot soldier in Dumbledore's Army."

According to Radcliffe, Albus Dumbledore's death focuses Harry on the task ahead, as he is now the one having to make the plans. But as Harry tries to fulfill Dumbledore's "assignment" to find and destroy the Horcruxes, he also has a crisis of faith. "How far is Harry willing to believe that Dumbledore is right and was doing everything he did for the right reasons," Radcliffe explains. "The more Harry finds out about Dumbledore he hadn't known, or feels had been kept from him, the more that faith is eroded away. There are some moments when it looks as if Harry is about to chuck in the towel and walk away from it completely. Thankfully, for both the wizarding populace and the film, which would be dramatically short if that was the case, he chooses to continue."

BEHIND THE MAGIC

For the other headmaster portraits, actors were shot on a blue-screen stage pretending to sleep. Then this film was given a painting-like effect digitally, "so it actually looks like the paintings are moving and asleep," says director Chris Columbus.

> "You should know . . . Professor Dumbledore . . . you meant a great deal to him."
>
> —MINERVA MCGONAGALL,
> *HARRY POTTER AND THE HALF-BLOOD PRINCE*

Daniel Radcliffe (Harry Potter) leapt upward onto a series of rising platforms hidden beneath the mountain of prop treasures to reach the Hufflepuff Cup in the Lestrange vault.

100 OBJECTS

174

96. HUFFLEPUFF CUP

Among the Horcruxes Voldemort created is one fashioned from a cup owned by Helga Hufflepuff, one of the four founders of Hogwarts. The cup has been placed in the Lestrange family vault in Gringotts for safekeeping, until Harry, Ron, and Hermione become aware of its location and are able to obtain it.

The Hufflepuff Cup was created for *Harry Potter and the Half-Blood Prince*, to be seen briefly in the Room of Requirement. Designer Miraphora Mina created a modest cup, inspired by "tiny golden goblets and thistle-shaped cups" she saw in the Victoria and Albert Museum. But as the seventh book had yet to be published, she was unaware there was supposed to be badger on it. The cup was refashioned for *Harry Potter and the Deathly Hallows – Part 2* with this new information.

Mina was also unaware that the cup would need to be replicated hundreds of times. A duplicating curse has been cast inside the Lestrange vault: Whenever a gold plate or silver coin is touched, it multiplies endlessly. An injection-molding machine ran on a twenty-four-hour schedule, creating copies of six different objects that ran into the thousands.

> "Are you thinking there's a Horcrux in Bellatrix's vault?"
>
> —HERMIONE GRANGER, *HARRY POTTER AND THE DEATHLY HALLOWS – PART 2*

OPPOSITE: Concept art of the Hufflepuff Cup by Miraphora Mina
TOP: The prop Hufflepuff Cup, replicated hundreds of times when the Geminio curse is activated within Bellatrix Lestrange's Gringotts vault in *Harry Potter and the Deathly Hallows – Part 2*
BOTTOM AND INSET: Harry Potter (Daniel Radcliffe) struggles to reach the real Hufflepuff Cup, hidden in the vaults in the dungeons of Gringotts bank. Harry uses the Sword of Gryffindor to finally reach the cup

97. RAVENCLAW'S DIADEM

Harry, Ron, and Hermione return to Hogwarts when Harry receives a vision of Rowena Ravenclaw, and believes that there's a Horcrux there associated with her.

Similar to the Slytherin Horcrux Locket, there were two versions of the Ravenclaw Horcrux Diadem created, though not for similar reasons. "It was scripted to be in *Harry Potter and the Half-Blood Prince*, and we did make one," recalls art director Hattie Storey. "Now it's so different, I'm glad it wasn't established in the sixth film." It appears in the home of Xenophilius Lovegood, who believes it is the real diadem. The first iteration, placed on a bust of Rowena Ravenclaw in the home, gives the suggestion of eagle wings in its design.

The diadem was redesigned for *Harry Potter and the Deathly Hallows – Part 2*. It was decided that emphasis should be placed on the eagle mascot of Ravenclaw house, and so Miraphora Mina, who designed both, placed the eagle's head at the top of the diadem, above a large, oval aquamarine stone. The wings are outlined in white stones, and its "body" and "tail feather" are made from two more aquamarines.

> "The lost diadem of Ravenclaw? Hasn't anyone heard of it? It's quite famous."
>
> "Yes, but Luna, it's lost. For centuries now. There's not a person alive today who's seen it."
>
> —LUNA LOVEGOOD AND CHO CHANG,
> *HARRY POTTER AND THE DEATHLY HALLOWS – PART 2*

OPPOSITE TOP: The prop Ravenclaw Diadem seen in *Harry Potter and the Deathly Hallows – Part 2*

OPPOSITE LEFT: Concept art by Adam Brockbank of the bust of Rowena Ravenclaw, topped with a stone version of her diadem, seen in *Harry Potter and the Deathly Hallows – Part 1*

FAR RIGHT: Harry finds the Ravenclaw Diadem hidden in the Room of Requirement, set inside a blue velvet-lined wooden box in *Harry Potter and the Deathly Hallows – Part 2*

BELOW AND OPPOSITE BOTTOM: An early concept of the Ravenclaw diadem by Miraphora Mina was fashioned into a practical prop for *Harry Potter and the Deathly Hallows – Part 1*, but never used in the films

BOTTOM: A faux bust of Rowena Ravenclaw created by Xenophilius Lovegood, displayed in his house in *Harry Potter and the Deathly Hallows – Part 1*

The Ravenclaw motto, "Wit beyond measure is man's greatest treasure," runs along the bottom of the diadem.

98. NAGINI

The snake Nagini is Voldemort's constant companion, first seen in *Harry Potter and the Goblet of Fire*. Nagini is the only other living Horcrux besides Harry Potter.

Calling her Voldemort's companion, according to Daniel Radcliffe, "doesn't quite fit this absolute creature of evil. She's almost the embodiment of Voldemort's mental state." Radcliffe felt the scenes with the snake were among the scariest of the films.

Nagini was a digital creation resembling a mash-up between an anaconda and a Burmese python, and twenty feet long. She appeared briefly in *Harry Potter and the Order of the Phoenix*, but for *Harry Potter and the Deathly Hallows – Parts 1 and 2,* Nagini had a much larger role, so the filmmakers wanted her to have a much more threatening presence. "It was very important we created a very believable, scary character," explains visual effects supervisor Tim Burke. "I felt that when we'd last seen her, she wasn't quite a real snake. In *Part 2*, she was going to have a lot of chances to scare the kids."

Burke convinced the studio to bring in a live python, which was sketched and filmed by the digital crew. One digital artist took high-resolution images of the snake's scales, which allowed the CGI crew to give Nagini the iridescence and reflective quality of snakeskin as well as truer, more vibrant colors. Nagini retained much of her python breed features, but with added characteristics from vipers in her brows and eyes for more animation. She was also given much sharper fangs that protruded from her mouth.

> "It's the snake. She's the last one. The last Horcrux."
>
> —HARRY POTTER,
> *HARRY POTTER AND THE DEATHLY HALLOWS – PART 2*

BEHIND THE MAGIC

For her appearance in *Harry Potter and the Deathly Hallows – Part 1* and *2*, movements of vipers and cobras were incorporated to enhance Nagini's serpentine slither.

TOP: Visual development art of Voldemort's companion, Nagini, exploring textures, pattern, and colors
BOTTOM LEFT: Nagini and Barty Crouch Jr. (David Tennant) takes care of the fetus-like Voldemort in *Harry Potter and the Goblet of Fire*
INSET: Visual development art of a snake-headed concept for Voldemort
OPPOSITE TOP: The prop Sword of Gryffindor seen in the Harry Potter films
OPPOSITE MIDDLE: Neville Longbottom wielded the Sword of Gryffindor in *Harry Potter and the Deathly Hallows – Part 2* and destroyed the final Horcrux, the snake Nagini
OPPOSITE BOTTOM LEFT: Daniel Radcliffe (Harry Potter) poses with the Sword of Gryffindor in a publicity still for *Harry Potter and the Chamber of Secrets*
OPPOSITE BOTTOM RIGHT: Images of the Sword of Gryffindor with Harry (Daniel Radcliffe) and inside the Sorting Hat from *Harry Potter and the Chamber of Secrets*

99. SWORD OF GRYFFINDOR

In addition to the first Golden Snitch Harry caught, Dumbledore tried to leave Harry a second bequest in his will—the sword of Godric Gryffindor. The Sword of Gryffindor, held in the Hogwarts headmaster's office, will present itself to any worthy Gryffindor, as it had in *Harry Potter and the Chamber of Secrets*.

To create the Sword of Gryffindor, the prop makers purchased a real sword for reference while at the same time researching medieval swords. The final sword was forged from bits and pieces of actual weaponry. "We went to one of our rental companies and brought in different swords," says property master Barry Wilkinson. "We laid them all out, and we picked the parts we liked—a blade from one, a handle from another, and then we made our own." Ruby-colored cabochons decorate the pommel and handle, and the image of a man inscribed on the grip is presumed to be Godric Gryffindor himself.

In *Harry Potter and the Deathly Hallows – Part 2*, Neville Longbottom finds a tattered Sorting Hat during the Battle of Hogwarts, and confronts Voldemort, pulling the Sword of Gryffindor from the hat. The sword he pulls out is no digital effect: the prop makers created a collapsible sword that unrolled as it was taken out, similar to a tape measure.

> "The Sword of Gryffindor. It's Goblin-made. . . . Dirt and rust have no effect on the blade. It only takes in that which makes it stronger."
>
> —HERMIONE GRANGER, *HARRY POTTER AND THE DEATHLY HALLOWS – PART 1*

100. ELDER WAND

The Elder Wand, said to be the most powerful wand in existence, is one of the Deathly Hallows, along with the Resurrection Stone and the Invisibility Cloak, that together make one master of Death. Voldemort has been actively pursuing the wand, even torturing Garrick Ollivander to reveal its location. "Voldemort is under the belief that whoever possesses the Elder Wand would have supremacy," says actor Ralph Fiennes (Voldemort), "but it's more complicated than that, much to his frustration." The Elder Wand has been in the possession of Albus Dumbledore since he defeated its former owner, the Dark wizard Gellert Grindelwald, and became master of the wand.

Knowing that the Hogwarts Headmaster was the possessor of the Elder Wand might have pressured the prop makers when it came to its design, but they actually had no idea of the importance of Dumbledore's wand when it was created. "We always tried to find interesting pieces of precious woods," says supervising modeler Pierre Bohanna, "We didn't want plain silhouettes [for the wands], so we chose wood that might have burrs or knots or interesting textures to create a unique shape to it." Unintentionally, the Elder Wand benefitted from this approach, and became one of the most distinctive wands created for the films. The Elder Wand was fashioned from a piece of English oak, with a bone inlay on the handle upon which runelike symbols are inscribed. "It's very thin as a wand," says Bohanna, "but it has these outcrops of nodules every two or three inches, so it's very recognizable, even from a distance." Bohanna considered the design simple, "but, obviously, it's the biggest gun on the set," he adds. "As far as wands are concerned, it's the one to beat all others."

Once Harry defeats Voldemort, he takes possession of the Elder Wand, and, already having the Cloak and Stone, "He could have ultimate power," says producer David Heyman. "But he doesn't want that. It was something that Dumbledore actually yearned for, that Dumbledore struggled with. But Harry doesn't want to have that responsibility. So he breaks the wand, and throws it away."

> **"If it's true what you say, that he has the Elder Wand, I'm afraid you really don't stand a chance."**
>
> —GARRICK OLLIVANDER TO HARRY POTTER,
> *HARRY POTTER AND THE DEATHLY HALLOWS – PART 2*

Voldemort acquires the Elder Wand after Dumbledore dies, snatching it from his tomb in an idea suggested by director David Yates, providing a staggering cliffhanger for *Harry Potter and the Deathly Hallows – Part 1*.

DEATHLY HALLOWS – PART 2

181

INDEX

Adrian Pucey, 65
Advanced Potion-Making, 67, 144, 165
Alastor Moody, 113, 122–123
Albus Dumbledore, 7, 10, 27, 39, 42, 57, 89, 94, 95, 96, 103, 108, 111, 113, 135, 148, 154, 155, 165
 Elder Wand, 180
 painting of, 173
 will, 160–161
Amortentia, 141
Amos Diggory, 92
Angel of Death statue, 112
Argus Filch, 42, 73, 129
Arthur Weasley, 51, 92, 116
Azkaban prison, 73, 75, 77, 149

Barron, David, 152
Bartemius Crouch Sr., 95
Barty Crouch Jr., 92, 113, 178
Basilisk, 67, 68
Beaters, 40
Beauxbatons Academy of Magic, 95, 96
Beguiling Bubbles potion, 141
Bellatrix Lestrange, 175
Bertie Bott's Every Flavor Beans, 26
Bill Weasley, 162
Bjelac, Pedrag, 96, 103
Black Lake, 107
Bliss, Rob, 86, 108, 112
Bludgers, 40–41
Boggart cabinet, 79
Bohanna, Pierre, 7, 34, 40, 45, 83, 94, 111, 140, 155, 165, 180
books, 7
 Advanced Potion-Making, 144
 Dark Arts Defense: Basics for Beginners, 126
 Gilderoy Lockhart's, 60–61
 The Monster Book of Monsters, 86–87
 The Tales of Beedle the Bard, 161, 162, 168
Borgin and Burkes, 154, 156, 157
Branagh, Kenneth, 58–59, 61

Break with a Banshee (Lockhart), 61
Broadbent, Jim, 150, 152, 153
Brockbank, Adam, 50, 63, 73, 87, 123, 138, 140, 141, 149
brooms, 7
 Alastor Moody's, 122–123
 Firebolt, 84–85
 Nimbus 2000, 36–37
 Nimbus 2001, 64
Buckbeak, 88, 89
Bullimore, Mark, 68, 156
Burke, Tim, 178
Burrow, 11, 65, 161
 clocks, 50, 51
 self-knitting machine, 52–53
Butterbeer label, 143
Butterbeer necklace, 119

Cantwell, Martin, 40
Care of Magical Creatures, 87
cat plates, 130–131
cauldrons, 7, 65
Cedric Diggory, 92, 103, 106, 112
Chamber of Secrets, 67, 68–69
Charing Cross Road, 17
Charms class feather, 35
chess game, 46–47
Cho Chang, 176
Chocolate Frogs, 27
Chudley Cannons, 52
Clifford, Veronica, 50

Coltrane, Robbie, 11, 17
Columbus, Chris, 13, 20, 21, 22, 26, 39, 47, 57, 83, 173
copperplate, 161
Court, Bryn, 112
Craig, Stuart, 7, 22, 27, 29, 33, 39, 58–59, 68, 83, 89, 95, 102, 104, 112, 123, 132, 135, 139, 153, 156, 166, 172
croakoa, 27
Crush Blush, 141
Crystal Cave scoop, 155
Cuarón, Alfonso, 73, 83, 84
Cupid Crystals potion, 141
cursed opal necklace, 154
curses, 144

Daily Prophet newspaper, 76–77, 92, 93, 117, 128
Dark Arts Defense: Basics for Beginners, 126
Dark Detectors, 88
Davis, Warwick, 35, 165
Dean Thomas, 34, 133
Death Eaters, 11, 65, 108–109, 113, 135, 149, 154
Deathly Hallows, 7, 42, 148, 180
Deathly Hallows necklace, 162–163
Defense Against the Dark Arts Class, 58–59, 79, 113, 123
Deluminator, 164, 165
Dementors, 27, 36
Dervish and Banges shop, 88
Dex (rat), 26
Diagon Alley, 7, 18, 138–139, 146, 149, 156
diary of Tom Riddle, 67
Dirigible Plum earrings, 119
Divination, 78
Dobby, 50
documents
 Albus Dumbledore's will, 160–161
 Dumbledore's Army sign-up sheet, 133
 Educational Decrees, 128–129
 Ministry of Magic, 116–117
Dolores Umbridge, 117, 126
 blood ink quill, 127
 cat plates, 130–131
 Educational Decrees, 128–129
door to the Chamber of Secrets, 68–69
dormitory beds, 33
Draco Malfoy, 30, 34, 36–37, 54, 57, 64, 144, 154, 156, 173
Dre Head, 17, 74
"Droste effect," 126
Dudley Dursley, 13
Dudman, Nick, 132, 172
Dumbledore's Army, 132, 133, 135, 151, 173
Durmstrang Institute, 95, 96

Educational Decrees, 128–129
Edwardus Limus, 87
Elder Wand, 7, 163, 180–181
Elixir of Life, 45
E.M.I. Potions Co., 150
End-of-Term Feast, 29
Enoch, Alfred, 133
Everlasting Eyelashes, 141

Fat Lady portrait, 73
Fawkes, 96
Fearn, Scot, 65
Felix Felicis potion bottle, 145
Felton, Tom, 30, 34, 36–37, 64, 156
Fiennes, Ralph, 180
Filius Flitwick, 35
Firebolt broom, 84–85
First Love potion, 141
Fleur Delacour, 96, 103, 162
Flirting Fancies potion, 141
floating cake, 50
Flying Ford Anglia, 54, 62

Fountain of Magical Brethren, 172
Fred Weasley, 26, 51, 52–53, 92, 128–129, 138, 140, 141
French, Dawn, 73

Gadding with Ghouls (Lockhart), 61
Gambon, Michael, 95, 96, 103, 108, 148
Garrick Ollivander, 18–19, 83, 180
George Weasley, 21, 51, 52–53, 92, 128–129, 138, 140
Gilderoy Lockhart, 58–59, 60–61, 68
Ginny Weasley, 39, 63, 67, 73, 92, 135
glasses, 14–15
Gleeson, Brendan, 113, 123
Goblet of Fire, 94, 95
Godric Gryffindor, 179
Golden Egg, 106–107

Golden Snitch, 7, 14, 38–39, 163
grandfather clock, 51
Great-Aunt Tessie, 101
Great Hall, 29, 95, 101, 102–105, 129
Great Western Railway, 22
Griffiths, Richard, 13
Grimmauld Place, 76, 124
Gringotts bank, 45, 68, 175
Grint, Rupert, 14, 26, 33, 40, 46, 54, 63, 76, 78, 88, 92, 101, 163, 165, 166
Gryffindor, 7, 29, 64, 73
 common room, 143
 dormitory beds, 33
 Quidditch team, 119

Hagrid. *see* Rubeus Hagrid
Half-Blood Prince, 144
Hall of Prophecy, 135

A Hard Day's Night (film), 22
Hare Patronus bracelet, 119
Harris, Paul, 35
Harris, Richard, 11, 57
Harry Potter, 7, 75, 76, 78, 124, 138, 142, 148, 150, 155, 161, 167, 172
 acceptance letter, 7, 12–13
 Advanced Potion-Making book, 144
 at The Burrow, 51, 52
 in the Chamber of Secrets, 68
 in the *Daily Prophet*, 77
 and Dolores Umbridge's blood ink quill, 127
 and Dumbledore, 173
 and the Elder Wand, 180
 Firebolt broom, 84–85
 and the floating cake, 50
 in the Flying Ford Anglia, 54
 glasses, 14–15
 and the Golden Egg, 106–107
 and Hagrid's motorbike, 10–11
 on Hogwarts Express, 22, 26, 27
 and Hufflepuff Cup, 174–175
 Invisibility Cloak, 42
 on the Knight Bus, 74
 leader of Dumbledore's Army, 133, 173
 at Little Hangleton Graveyard, 112, 113
 and Marauder's Map, 80
 Mirror of Erised, 42
 and *The Monster Book of Monsters*, 87
 Nimbus 2000 broom, 36–37
 at Ollivanders, 18
 Pensieve memories, 108–109, 111
 at Platform 9-¾, 20–21
 Polyjuice Potion, 65
 and Portkeys, 92
 Quidditch-playing, 39, 40
 and Ravenclaw Diadem, 176–177

Rita Skeeter interview, 93
Sneakoscope gift, 88
Sorting Ceremony, 30
and Tom Riddle's diary, 67
trunk, 28
wand, 83
and winged keys, 44
wizard chess play, 47
at the Yule Ball, 101
Hart, Ian, 17
Heartbreak Teardrops, 141
Hedwig, 54
Heir of Slytherin, 65
Helga Hufflepuff, 175
Hemming, Lindy, 61
Hermione Granger, 7, 15, 22, 30, 35, 39, 42, 44, 45, 47, 54, 76, 84, 92, 103, 106, 126, 138, 167, 172, 175, 179
in the Chamber of Secrets, 69
Dumbledore's Army formation, 132, 133
Dumbledore's bequest, 161, 169
Polyjuice Potion, 65
Sneakoscope gift, 88
Time-Turner, 89
Yule Ball, 101
hero props, 7, 161
Heyman, David, 7, 35, 124, 133, 180
Hibon, Ben, 168
Highgate Cemetery, 112
Hippogriffs, 88, 89
Hogsmeade, 75, 80–81, 88, 132
Hogs's Head Inn Hog's Head, 132
Hogwarts Apothecary, 147
Hogwarts Express, 20, 22–25, 26, 142
Hogwarts High Inquisitor, 129
Hogwarts Library, Restricted Section, 42, 43
Hogwarts Potion Dept., 146
Hogwarts School of Witchcraft and Wizardry, 7, 22, 27, 42, 80, 95, 96–99
acceptance letter, 7, 12–13
Board of Governors, 57
coat of arms, 13
crest, 28
motto, 28
Horace Slughorn, 7, 108, 111, 141, 144, 146, 147, 148, 150, 151, 165

hourglass, 152–153
potions trunk, 151
Horcruxes, 7, 67, 69, 148, 166, 175, 176, 178
hourglasses, 7, 152–153
House Cup, 29
House Points Hourglasses, 29
Howlers, 7, 62–63
Hufflepuff Cup, 69, 174–175
Hufflepuff house, 29
Hurt, John, 19, 165

Ianevski, Stanislav, 96, 103
ice sculptures, 102, 103
Ifans, Rhys, 119, 162–163
Igor Karkaroff, 96, 103
Ingleby, Lee, 75
Invisibility Cloak, 7, 42, 163, 180
Isaacs, Jason, 57

Joseph, Eddy, 39, 40

Katie Bell, 7, 154
keys
Portkey, 92
winged, 44
King's Cross Station, 20, 21
Kissing Concoction, 141
kittens, 131
Knight Bus, 74
knitting machine, 52–53

Knockturn Alley, 149, 154, 156
Lancaster, Shirley, 52
Leaky Cauldron, 16–17, 75, 87
Leavesden Studios, 7, 112
Lee Jordan, 40
Legato, Robert, 44
letters
 Hogwarts Acceptance, 7, 12–13
 Howlers, 7, 62–63
 Ministry of Magic, 116–117
Lewis, Matthew, 31, 34
Lily Evans, 31
Lima, Eduardo, 7, 75, 77, 87, 101, 117, 124, 129, 140, 150, 151, 161, 168, 169
Liquid Luck, 165
Little Hangleton Graveyard, 92, 112
Lloyd-Hughes, Henry, 103
Lloyd-Pack, Roger, 95
lockets, 7, 166–167, 172, 176
Love Is Blind Eye Serum, 141
love potions, 141
Luchino Caffé, 164
Lucius Malfoy, 57, 64, 135, 149
Luna Lovegood, 118, 163, 176
 Dirigible Plum earrings, 119
 Spectrespecs, 142
Lynch, Evanna, 118, 119, 143, 165

Madam Hooch, 37
Magic is Might statue, 172
Magician's Hat statue, 138–139
Makovsky, Judianna, 42
Marauder's Map, 80–81
Marcus Flint, 64
Marge Dursley, 74

Marvolo Gaunt's ring, 148, 163
McKinstry, Peter, 165
McMillan, Stephenie, 7, 18, 28, 33, 52, 58, 78, 79, 96, 102–103, 104, 126, 130, 135, 151
Melling, Harry, 13
memory cabinets and bottles, 111
Mina, Miraphora, 7, 13, 20, 28, 61, 63, 75, 77, 80–81, 87, 89, 94, 95, 101, 106, 107, 111, 117, 124, 126, 129, 140, 142, 144, 146, 148, 149, 150, 152, 153, 154, 155, 161, 166, 168, 169, 175, 176
Minerva McGonagall, 10, 13, 30, 54, 68, 75, 103, 154, 173
Ministerial Wizarding Registration Department (MWRD), 117
Ministry of Magic, 57, 75, 76, 77, 129, 149
 documents, 116–117
 Hall of Prophecy, 135
 logo, 117
 Magic is Might statue, 172
 Wizarding Union, 117
Mirror of Erised, 42, 43
Moaning Myrtle, 65
Molly Weasley, 21, 52–53, 62–63
The Monster Book of Monsters, 86–87
Moste Potente Potions, 65
motorbike, 10–11
Mr. Mulpepper's apothecary, 146
Mrs. Mason, 50
Mrs. Norris, 42
Mudbloods and How to Spot Them, 117
Muggle-Born Registration Commission, 116, 117, 130
Murray, Devon, 35
Murray, Julian, 172

Nagini, 178
Narcissa Malfoy, 156
necklaces, 7
 Butterbeer necklace, 119
 cursed opal necklace, 154
 Deathly Hallows, 162–163
 Salazar Slytherin's locket, 166–167, 172, 176
Neville Longbottom, 31, 33, 34, 79, 135, 178, 179
Newell, Mike, 96
Newton, Dale, 168
Nicolas Flamel, 42, 44

Nighy, Bill, 161, 165
Nimbus 2000 broom, 36–37
Nimbus 2001 broom, 64
Nimbus Broom Racing Company, 64
Number Four, Privet Drive, 10, 50, 74, 165

Oldman, Gary, 75, 124
Oliver Wood, 39, 41
Ollivanders, 7, 18–19
"Olton Hall" (locomotive), 22
Order of the Phoenix, 65, 76
origami, 63
Owl Post, 62

paintings
 of Albus Dumbledore, 173
 Fat Lady portrait, 73
 of Gilderoy Lockhart, 58–59
Parseltongue, 68, 167
Pattinson, Robert, 103
Pensieve, 108–109, 110–111
Percy Weasley, 33
Peter Pettigrew, 80
Petunia Dursley, 13, 50
Phelps, James, 92, 138
Phelps, Oliver, 21, 138
Platform 9-¾, 28
 sign, 21
 train ticket, 20
Plum earrings, 119
Poésy, Clémence, 96, 103
Polyjuice Potion, 113, 172

Polyjuice Potion cauldron, 65
Portkey, 92, 95
portrait of *Lord John Stuart and his brother, Lord Bernard Stuart* (Van Dyck), 58
potion bottle labels, 146
potions
 bottle labels, 146
 Felix Felicis, 145
 love potions, 141
 Polyjuice Potion, 116, 165
potions bottles, 7
Power, Dermot, 84, 88
Pratt, Roger, 102
Privet Drive, 10, 50, 74, 165
Prophecy Globe, 135
Puking Pastilles, 7, 140

Quaffles, 40–41
Queensway Tunnel, 10
The Quibbler magazine, 120–121, 142
Quick-Quotes Quill, 92, 93
Quidditch, 7, 14, 119
 Bludgers, 40–41
 Firebolt broom, 84
 Golden Snitch, 39
 Nimbus 2000 broom, 36
 Nimbus 2001 broom, 64
 Quaffles, 40–41
 World Cup, 92
quills
 Dolores Umbridge's blood ink quill, 127
 Rita Skeeter's Quick-Quotes Quill, 127
Quirinus Quirrell, 17

Radcliffe, Daniel, 11, 13, 14–15, 20, 21, 30, 36–37, 39, 42, 44, 50, 51, 54, 57, 67, 75, 76, 78, 80, 83, 84, 87, 88, 101, 106, 108, 111, 112, 124, 133, 144, 150, 153, 154, 163, 165, 166, 173, 175, 178
Ravenclaw house, 29, 177
Ravenclaw's Diadem, 176–177
Reguius Black, 125
Regulus Arcturus, 166
Remembrall, 34
Remus Lupin, 27, 76, 79, 80
Resurrection Stone, 7, 39, 148, 163, 180
Richardson, John, 10, 13, 54, 68, 93
Richardson, Miranda, 92
Rickman, Alan, 79, 103, 146, 154
Rita Skeeter, 77, 92, 93
Roger Davies, 103
Ron Weasley, 7, 14, 22, 26, 27, 33, 36, 40, 42, 44, 47, 51, 52–53, 64, 73, 76, 78, 92, 123, 132, 133, 138, 144, 151, 161, 164, 165, 168
 broken wand, 54
 in the Chamber of Secrets, 68, 69
 in the Flying Ford Anglia, 54
 Howler, 62–63
 Sneakoscope gift, 88
 Yule Ball, 101
Room of Requirement, 80, 156, 175, 177
Rowena Ravenclaw, 176
Rowling, J. K., 83, 124
Royal Enfield, 10–11
Royal Pavilion, 101, 103
Rubeus Hagrid, 10–11, 17, 18, 20, 45, 87
Rufus Scrimgeour, 161, 165, 169

Safer, Tolga, 96
Salazar Slytherin's locket, 166–167, 172, 176
Scabbers, 26
Scottish Highlands, 22
Seamus Finnigan, 33, 35, 63, 84
Seekers, 7, 39, 64
self-knitting machine, 52–53
Severus Snape, 31, 79, 103, 108, 111, 144, 146, 154, 173
signs
 Leaky Cauldron, 17
 Ollivanders, 18
 Platform 9-¾, 21
sign-up sheet, Dumbledore's Army, 133
Sirius Black, 73, 77, 84, 88, 89, 135, 166
 family tapestry, 124–125
 Wanted poster, 75
Skiving Snackbox, 140
Slug & Jiggers apothecary, 146, 150
Slug Club Christmas Party, 119
Slytherin house, 29, 64
Smith, Maggie, 11, 30, 103, 154
snakes, 68
Sneakoscope, 88
Sorcerer's Stone, 7, 42, 44, 45
Sorting Ceremony, 30
Sorting Hat, 30–31, 179
Spectrespecs, 142
Spriggs, Elizabeth, 73
Stan Shunpike, 74, 75
statues
 Angel of Death, 112
 Magic is Might, 172
 Magicians Hat, 138–139
 Puking Pastilles Display, 140

Staunton, Imelda, 127, 128–129
Stevens, Gert, 39, 44
Storey, Hattie, 7, 83, 140, 148, 151, 156, 176
Sword of Gryffindor, 31, 166, 167, 178, 179
Sybill Trelawney, 78, 135

The Tales of Beedle the Bard, 161, 162, 168–169
teacups, 78
Temime, Jany, 73, 119
Tennant, David, 178
Ten-Second Pimple Vanisher, 141
tessomancy, 78
Thestrals, 119
Thewlis, David, 76, 79, 80
Three Broomsticks, 75, 143, 154
Time-Turner, 88, 89
Tom Riddle, 67, 108, 111, 148, 152
Triumph Bonneville T120, 10
Triwizard Tournament, 92, 94, 95
 Golden Egg, 106–107
 Triwizard Cup, 77, 92, 94, 112
 Welcome Feast, 96–99
 Yule Ball, 101–105
Trolley Witch, 26, 27
trunks
 Alastor Moody's, 113
 Harry's, 28
 Horace Slughorn's potions, 151
typography, 20

Van Dyck, Anthony, 58
Vanishing Cabinet, 156–157
Vernon Dursley, 13, 74
Victoria and Albert Museum, 175
Viktor Krum, 96, 103
Voldemort, 7, 22, 44, 57, 67, 108, 112, 117, 133, 135, 148, 149, 151, 163, 178, 180–181

Wakefield, Lauren, 150
Walters, Julie, 21, 52
wand boxes, 18–19
Wanderings with Werewolves (Lockhart), 61
wands, 7
 Elder Wand, 7, 163, 180–181
 Harry's, 83
 Lucius Malfoy's wand cane, 57
 Ron's broken wand, 54
 "swish and flick" movement, 35
Wanted posters
 Death Eaters, 149
 Sirius Black, 75
Watson, Emma, 14, 30, 39, 65, 76, 84, 88, 92, 101, 103, 106, 144, 154, 163, 165
Weasley's Wizard Wheezes, 7, 88
 love potions, 141
 Magician's Hat statue, 138–139
 Puking Pastilles Display, 140
Whomping Willow, 36, 54
Wilkinson, Barry, 7, 93, 94, 179
Williams, Mark, 51, 92
Williamson, Andrew, 17, 50, 78, 135, 156
Windtorte Pudding, 50
winged keys, 44
Winick, Ruth, 26, 27
Wizard Waltz, 101
wizard's chess game, 46–47
Wonderwitch love potions, 141
Wrackspurts, 142
Wright, Bonnie, 39, 67, 92

Xenophilius Lovegood, 119, 120, 162–163, 176

Yates, David, 77, 109, 119, 133, 135, 156, 161, 181
Yule Ball
 Great Hall decorations, 102–105
 invitation, 101
 Programme, 101

ZSL London Zoo, 146

INSIGHT
EDITIONS

PO Box 3088
San Rafael, CA 94912
www.insighteditions.com

Find us on Facebook: www.facebook.com/InsightEditions
Follow us on Instagram: @insighteditions

Copyright © 2024 Warner Bros. Entertainment Inc. WIZARDING WORLD characters, names, and related indicia are © & ™ Warner Bros. Entertainment Inc. WB SHIELD: TM & © WBEI. Publishing Rights © JKR. (s24)

All rights reserved. Published by Insight Editions, San Rafael, California, in 2024.

No part of this book may be reproduced in any form without written permission from the publisher.

ISBN: 979-8-88663-115-9

Publisher: Raoul Goff
SVP, Group Publisher: Vanessa Lopez
VP, Creative: Chrissy Kwasnik
VP, Manufacturing: Alix Nicholaeff
Designer: Lola Villanueva
Editorial Director: Lia Brown
Editor: Stephen Fall
Editorial Assistant: Sami Alvarado
Executive Project Editor: Maria Spano
Senior Production Editor: Nora Milman
Senior Production Manager: Greg Steffen
Senior Production Manager, Subsidiary Rights: Lina s Palma-Temena

ROOTS of PEACE REPLANTED PAPER

Insight Editions, in association with Roots of Peace, will plant two trees for each tree used in the manufacturing of this book. Roots of Peace is an internationally renowned humanitarian organization dedicated to eradicating land mines worldwide and converting war-torn lands into productive farms and wildlife habitats. Roots of Peace will plant two million fruit and nut trees in Afghanistan and provide farmers there with the skills and support necessary for sustainable land use.

Manufactured in China by Insight Editions

10 9 8 7 6 5 4 3 2 1